IMAGES
of America

SUMTER COUNTY

IMAGES
of America

SUMTER COUNTY

Dr. Alan Brown

ARCADIA
PUBLISHING

Published by Arcadia Publishing
Charleston, South Carolina

Printed in the United States of America

Library of Congress Control Number: 2014946041

For all general information, please contact Arcadia Publishing:
Telephone 843-853-2070
Fax 843-853-0044
E-mail sales@arcadiapublishing.com
For customer service and orders:
Toll-Free 1-888-313-2665

Visit us on the Internet at www.arcadiapublishing.com

This book is dedicated to Dr. Tina Jones, a fine student, a dedicated professor and administrator, and a dear friend.

CONTENTS

ACKNOWLEDGMENTS

The creation of this book would have been impossible without the assistance of a number of individuals on the University of West Alabama (UWA) campus. For almost two months, Sheila Limerick and Christin Loehr, librarians at the Julia Tutwiler Library, directed me to several collections and scrapbooks that proved to be a treasure trove of old photographs. Amy Christiansen, archivist at the Center for the Study of the Black Belt, helped me locate and scan a large number of photographs in the Derby Collection. I heavily depended on the technical expertise of Gena Robbins, public relations specialist for the Division of Educational Outreach, in changing the dimensions of the cover photograph. Dustin Prine, media specialist for the College of Liberal Arts, burned a CD for me consisting of photographs that Dr. Tina Jones had accumulated in her research for the book *Bridging Time: 175 Years at the University of West Alabama*. Greg Jones, English instructor and adviser for the *muse*, assisted me with incorporating the photographs into the manuscript. Dr. Joe Taylor, director of the Livingston Press, provided me with a number of historical photographs from his extensive files.

I also reached out to a number of private individuals. Former UWA librarian Gregor Smith loaned me several of her family photographs. Lolita Smith presented me with a number of photographs from her own collection and from members of her church. Virginia Ozment opened the Sumterville Community Center for me so that I could scan eight photographs hanging on the wall. David Hatcher, curator of the Cuba Museum, allowed me to work in the museum for a number of hours over two days. Susan Parker and Betty Lou Jones, volunteers at the Jimmie Rogers Museum, generously allowed me to scan a photograph of Jimmie as an infant. Maxine McCluskey, secretary of the College of Business, supplied me with a number of photographs from Gainesville. I probably would not have found any photographs from Ward either had Corrie Rew not permitted me to scan the photographs in the Ward Visitors' Center. Most of the Emelle and Ramsey Station photographs were provided by Lolita Smith. Margaret Ramsay loaned me her photographs of Farview and her family members.

Finally, I would like to thank Julia Simpson, title manager at Arcadia Publishing, for providing me with the guidance I needed to create this book.

INTRODUCTION

In 1804, the US government began negotiating with the Choctaw chiefs for a vast tract of land that had been owned by the Choctaw since 1797. On September 27, 1830, representatives of the US government met with those of the Choctaw nation on the banks of Dancing Rabbit Creek in Macon, Mississippi, to sign a treaty ceding the Choctaw lands west of the Tombigbee River to the United States. On December 18, 1832, the Alabama legislature created Sumter County, Alabama, located in the west-central portion of the state. A commission appointed by Gov. John Gayle selected the present site of Livingston, Alabama, as the county seat.

When French explorers from Mobile, Alabama, arrived in what is now Sumter County, it had been divided into four Indian villages. Jean-Baptiste Le Moyne, sieur de Bienville, constructed Fort Tombecbee as a trading post on a chalk cliff in what is now Eppes, Alabama. A number of French, Spanish, and English settlers—nicknamed "squaw men" because they had married Indian women—received land under a provision in an article of the Treaty of Dancing Rabbit. Thousands of people from Kentucky, Virginia, and the Carolinas settled in towns like Livingston. Throughout most of the 19th century, farming was the primary occupation. Cotton, sweet potatoes, and corn were grown on small farms and plantations scattered throughout Sumter County. Prior to the Civil War, slaves did most of the work on plantations. Because of its proximity to the Tombigbee River, Gainesville became the largest inland shipping port of cotton in the entire world. By 1840, Sumter County's large cotton production had made it one of the wealthiest and most heavily populated parts of the state. The population was made up of 22,000 African Americans and 8,000 whites.

Sumter County's prosperity came to an abrupt end following the boll weevil infestation in the early 1900s. Farmers attempted to replace cotton with a variety of other crops, but without much success. The farmers of Sumter County suffered even more during the Great Depression, although the vegetables grown in their truck gardens enabled them to fare better than people living in the cities at the time. Today, little cotton is grown in Sumter County. In fact, only 3.2 percent of the workforce makes a living in agriculture. Cattle is the major agricultural product in Sumter County, and forestry is the primary industry. Almost half the workforce in Sumter County is employed in manufacturing, educational services, health care, and social assistance. Sumter County was once one of Alabama's wealthiest counties, and now it is one of the poorest.

The 900 miles of land that make up Sumter County are part of what has come to be known as the Black Belt, which derived its name from the region's rich black topsoil and the large number of African Americans who worked the land, first as slaves and then as sharecroppers. The economic inequality between blacks and whites living in Sumter County was not addressed until the Civil Rights movement of the 1950s. In one of the last-known cases of slavery in US history, Sumter County residents Fred N. Dial and Oscar Edwin Dial were convicted in 1954 for holding two black men as virtual prisoners on the farm where they worked.

Ironically, the poverty and illiteracy that have plagued African Americans in Sumter County for so many years also preserved many of their folk traditions. Renowned ethnomusicologists like Alan and John Lomax, Harold Courlander, and Ellie Siegmeister trekked hundreds of miles to Sumter County from the 1930s through the 1960s to record the spirituals, work songs, ring game songs, and blues that people were still singing in Sumter County. Livingston native Ruby Pickens Tartt not only assisted the Lomaxes with the task of collecting folk songs in Sumter County but also collected folk tales, legends, and life histories of former slaves from the people who lived in the red clay hills of Sumter County. For years, African Americans have sold their baskets and quilts at venues like the Sucarnochee Folklife Festival. Today, the people of Sumter County are proud of their past, and they celebrate it by passing these traditions down to their children and grandchildren.

The University of West Alabama, which has been serving the educational needs of the region since 1835, has taken great strides to keep the history, culture, and natural resources of Sumter County alive. Since its inception in 2012, the Center for the Study of the Black Belt has provided educational programs to grade school teachers, collected oral histories with the assistance of Volunteers in Service to America (VISTA) workers, offered classes in crafts like twining to the community, and established the Black Belt Garden, the Black Belt Archives, and the Black Belt Hall of Fame on the UWA campus. The fact that such a center exists stands as proof that there is much more to Sumter County than barbecue clubs, hunting camps, and antebellum homes.

One

THE EARLY YEARS

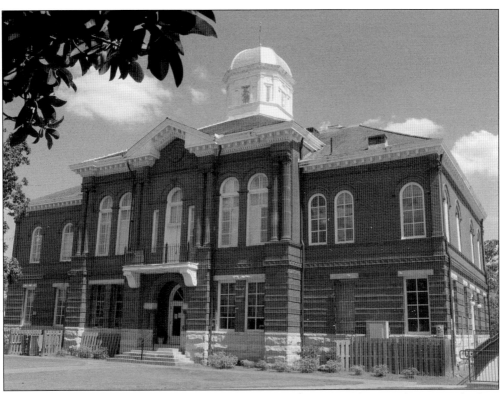

After Sumter County was created by the state legislature in 1832, a log courthouse was built in Livingston, the county seat. It was replaced by a frame courthouse in 1839. After it burned in 1901, the present Beaux-Arts courthouse was constructed a year later. The cornerstone was laid on July 9, 1902. The ceremony, which was presided over by former lieutenant governor J.G. Harris, included a public barbecue. Today, Sumter County consists of two cities, Livingston and York; five towns, Cuba, Emelle, Eppes, Gainesville, and Geiger; two census-designated places (CDPs), Bellamy and Panola; and two unincorporated communities, Intercourse and Ward. (Photograph by author.)

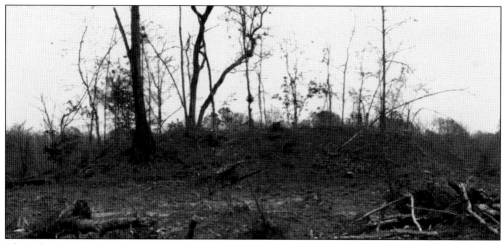

The Alamuchee Creek mound was built between 300 and 450 CE. This truncated rectangular mound is 2.5 meters high, with a ramp on the southeastern slope. It had been abandoned by 900 CE, but the Mississippians reoccupied it in 1100 CE. Sometime in the 19th century, the early settlers dug at least three graves on top of the mound and enclosed them with bricks. These graves were disturbed by looters in the 2000s. (Courtesy of Ashley Dumas and Steven Meredith.)

Before the arrival of the Europeans, the Choctaw tribe possessed millions of acres of land in Mississippi and western Alabama. By the late 1700s, approximately 15,000 Choctaw lived in the Southeast. Even though the Choctaws allied themselves with the United States in the Creek War of 1813–1814, they were forced to cede land in the Treaty of Fort St. Stephens. After surrendering more land east of the Mississippi River, most of the Choctaws were removed to Oklahoma by George Strother Gaines. Depicted in the photograph is Willi Martin, a Choctaw Indian who lived in Sumter County in the early 1900s. He assisted Dr. Robert D. Spratt with the spelling of Choctaw names in the book *A History of the Town of Livingston*. (Courtesy of Joe Taylor.)

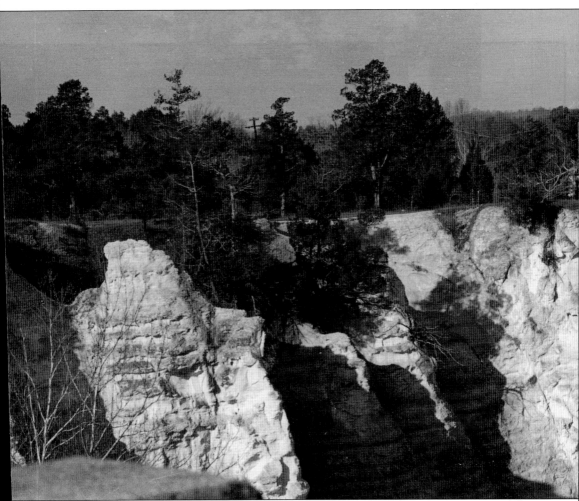

Concerned that the British were encroaching upon French holdings in Louisiana, Gov. Jean-Baptiste Le Moyne de Bienville ordered Capt. Joseph Christophe de Luser to begin construction of a fort on top of the 80-foot chalk cliff outside of present-day Eppes in 1735. When the fort was completed in 1737, it consisted of nine buildings, including a powder magazine, a prison, and barracks for the 30 soldiers stationed there. The French abandoned the fort in 1763, following the signing of the Treaty of Paris. In 1766, the British occupied the fort, which they renamed Fort York, but they abandoned it two years later. When the Spanish took over the site in 1792, little of the original structure was left, so they replaced it with an earthen structure. The Spanish were forced to leave the site in 1797 according to the Treaty of San Lorenzo, which ceded the land to the United States. For almost 200 years, Fort Tombecbee was known only to a few locals, but in 1980, interest in the old fort was revived when an archaeological team from the University of West Alabama began excavating the site. Excavations continued in the 2000s under the direction of UWA archaeologist Dr. Ashley Dumas. (Courtesy of Ashley Dumas.)

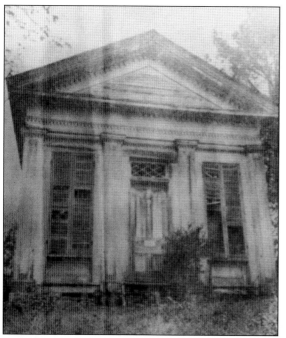

Col. Moses Lewis founded Gainesville on land above the Tombigbee River in the 1830s. Because of its ideal location, Gainesville became the third most populous town in Alabama in the 1840s. When the historic Gainesville Bank was founded in 1835, its first president was A.A. Winston. It was one of the few banks in Alabama that printed its own money. (Courtesy of the Sumter County Historical Society.)

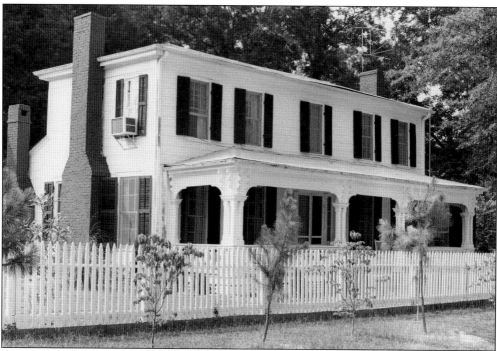

In 1865, Edward Kring (1836–1910) built this vernacular I-type house at the corner of Spruce and South Church Streets in Gainesville. The name *I-house* is derived from the structure's common occurrence in the rural farm states of Illinois, Indiana, and Iowa, all of which begin with *I*. Kring was one of the leading builders in Gainesville. He was the contractor for the Methodist and Episcopal churches built in the 1870s. He also served as the Sunday school superintendent in the Methodist church for many years. (Courtesy of the Sumter County Historical Society.)

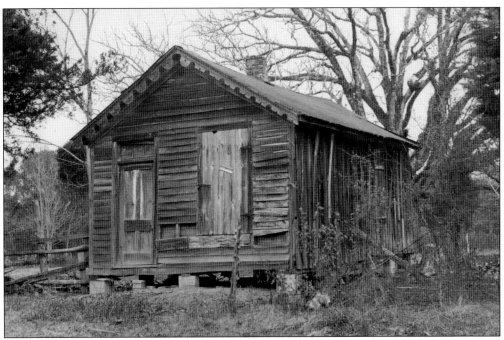

Edward Kring built the Coffin Shop in 1860. Customers picked out the wood and fabric for the coffins, which were custom built. The Coffin Shop is the only building to survive the devastating fire in Gainesville's commercial district on March 16, 1881. The fire destroyed the entire block, which consisted of 12 businesses and offices, including the newspaper office. Locals referred to the large tree behind the Coffin Shop as "the hanging tree." At 15.7 feet in circumference, it was the largest post oak in Alabama. The tree blew down during a storm in 2012. (Both, courtesy of the Sumter County Historical Society.)

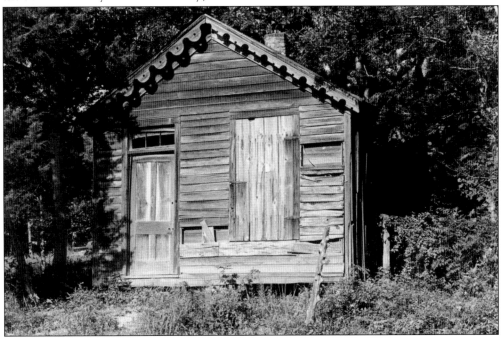

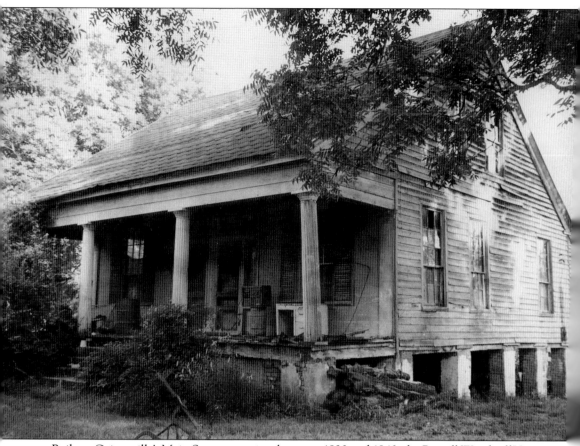

Built on Gainesville's Main Street sometime between 1830 and 1840, the Russell-Woodruff House was probably owned by W.H. Russell (1806–1878), a Yankee merchant who came to Gainesville from New Hampshire. Because so many Northerners lived on Main Street, it became known as "Yankee Street." The old house is the only one in Gainesville that has two front rooms connected by a wide double-leaf door. (Courtesy of the Sumter County Historical Society.)

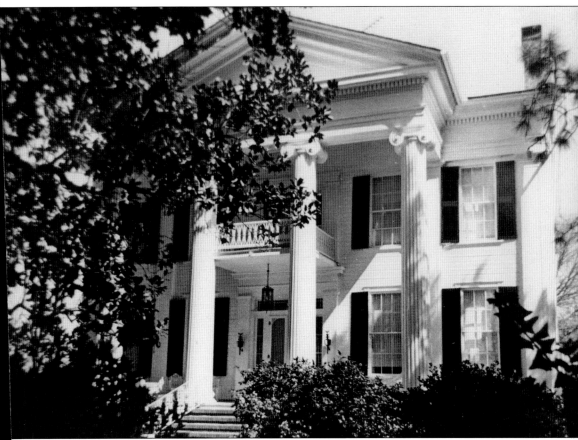

The Magnolia, built in 1845, is the grandest antebellum home in Gainesville. Col. Green G. Mobley (1806–1877) moved to Gainesville from South Carolina with his second wife. Two of the original outbuildings are still standing—a brick kitchen on the southeast corner and a brick smokehouse on the northeast corner. (Courtesy of the Sumter County Historical Society.)

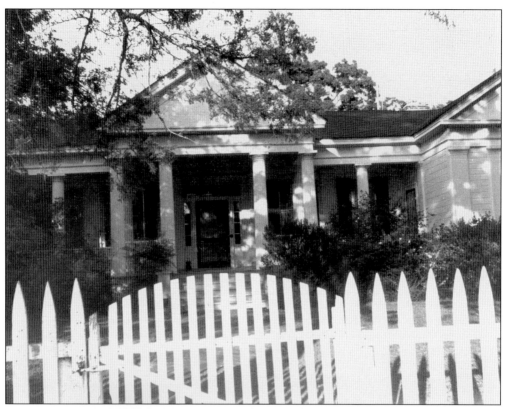

In 1845, Aduston Hall was built as a summer home for Amos Travis, a resident of Mobile. The John Aduston Rogers family purchased this Greek Revival cottage in 1895. It is the only antebellum home in Gainesville to retain all its original buildings. (Courtesy of the Sumter County Historical Society.)

John Aduston Rogers Sr. served as a member of the Constitutional Convention of 1901. He was elected to the state senate for the following terms: 1894–1897, 1902–1906, 1918–1922, and 1934–1938. He also served on the board of trustees of Auburn University and the University of Alabama. In 1923, he became chairman of the Highway Commission. (Courtesy of the Sumter County Historical Society.)

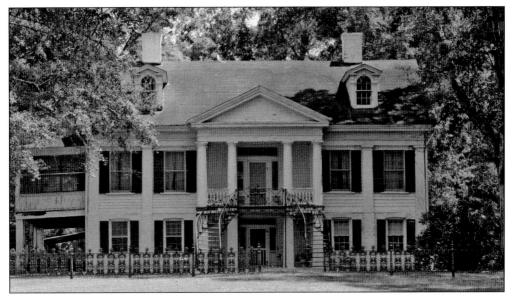

Architect Hiram W. Bardwell built Lakewood for Joseph Lake in 1840. The iron staircases were later added to the front of the Greek Revival house. The rear porch and the porch on the north side of the house were partially enclosed as a kitchen. In 1936, the wooden shingles were replaced by asbestos shingles. Julia Tutwiler lived at Lakewood while serving as president of the Alabama Normal School. (Photograph by author.)

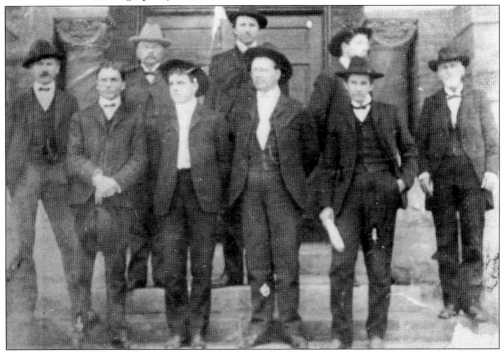

In 1906, these were some of the most influential businessmen in Livingston. They have been identified on the photograph as follows: (from left to right) Ed Wrenn, James R. Jackson, Charles J. Brockway, M.E. McConnell, Thomas F. Seale, W.W. Patton, R.B. Patton, J.C. Travis, and Capt. W.A.C. Jones. (Courtesy of Joe Taylor.)

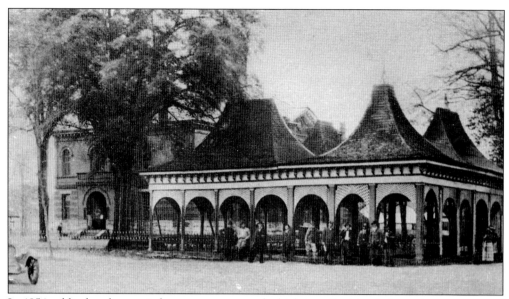

In 1854, a blind mule was tied to an auger around which it walked in circles to bore a source of water for Livingston. Dr. R.D. Webb and M.C. Houston kept records of the various strata bored through by the auger. Work was completed in 1857. At first, people were disappointed by the taste of the water because it was so salty. However, after Houston declared that the mineral water had eased his indigestion, others began drinking it as well. The water eventually ran out, and a pit was dug so that the water could run more freely. An elaborate wood pavilion with a Chinese-style roof was built over the well. (Courtesy of the Sumter County Historical Society.)

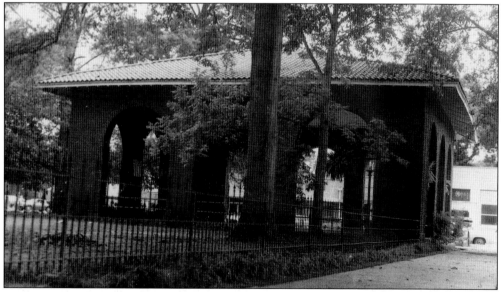

In 1904, when the water flow slowed down once again, G.B. Fellows installed a hand pump, which was replaced by an electric pump in 1928. A more substantial brick structure, shown here in the 1970s, was built in 1924. By the 1990s, engineers had determined that the pavilion was no longer safe, so it was removed in 1999. The present brick pavilion was built in 2005. Water still flows from a spigot inside the pavilion, but it is barely drinkable. (Courtesy of the Sumter County Historical Society.)

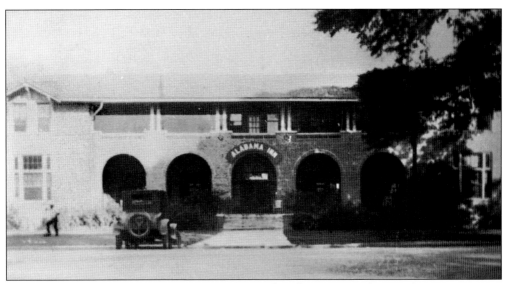

Thanks to the mineral water provided by the Bored Well, Livingston became known as a resort town in the early 20th century. Several hotels in Livingston, such as the Artesian Hotel and the Planters Hotel, catered to the visitors who had come to sample the Bored Well's curative waters. After the Planters Hotel was torn down, it was replaced by a frame store owned by R.W. Ennis, which in turn was replaced by the Alabama Inn. Under the management of Cameron Glover, the inn opened for business in March 1924. Lillybeck Chapman Cobb operated the hotel after Glover resigned. She was succeeded by a Mr. Washburn of Meridian, Mississippi. The Alabama Inn was destroyed by a fire on February 22, 1929. (Courtesy of the Sumter County Historical Society.)

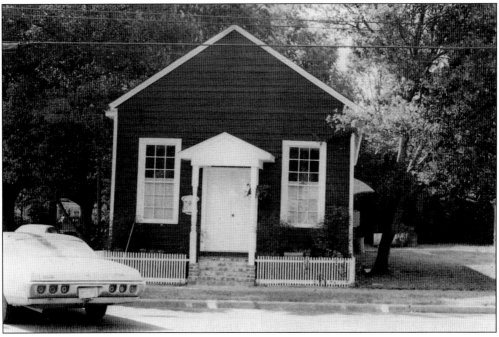

One of the first permanent structures in Livingston was this little schoolhouse, built sometime before 1850. With its original ceiling beams and wood floor, the cottage has served as the office of attorney Bob Seale for many years. (Courtesy of the Sumter County Historical Society.)

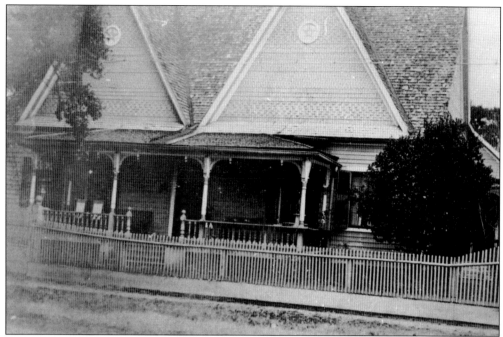

The double-gabled log house on Madison Street in Livingston was the home of newspaperman D.H. Trott. The next occupant was Confederate officer Capt. E.W. Smith. Other owners have included Mr. and Mrs. W.J. Nichols, Mr. and Mrs. Ed L. Mitchell, and Mr. and Mrs. Robert E. Upchurch. Over the years, wood siding and several rooms have been added to the original log structure. (Courtesy of Joe Taylor.)

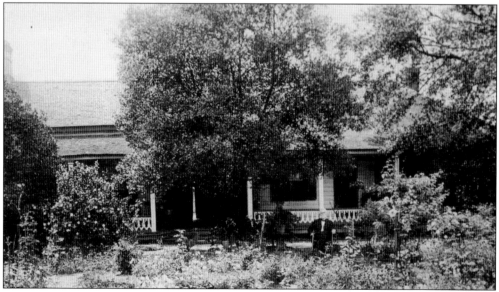

Capt. W.A.C. Jones, seated in front of his home in Livingston, served in the Confederate army. Trained as a civil engineer before the war, Captain Jones designed the Alamuchee Bridge, which is now on the University of West Alabama campus. He became one of Livingston's most prominent citizens. His home, now known as the Spence-Moon House, was purchased by the Sumter County Historical Society in 1987. (Courtesy of Joe Taylor.)

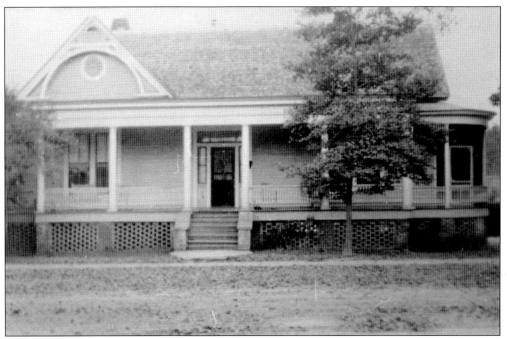

James P. Spratt was one of a number of settlers from South Carolina who moved to Livingston after the signing of the Treaty of Dancing Rabbit. As a cadet at the Citadel, he witnessed the bombardment of Fort Sumter. James Spratt's son Robert D. Spratt worked for the US Public Health Service. In the 1920s, he wrote *A History of the Town of Livingston, Alabama.* (Courtesy of Joe Taylor.)

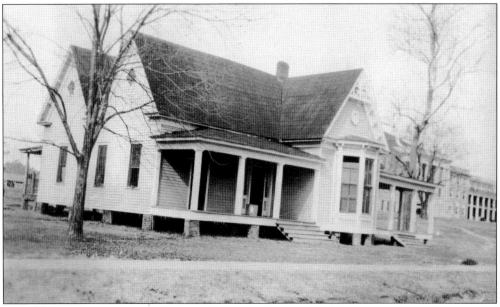

Col. T.B. Wetmore, a lawyer, built this house in Livingston. Wetmore had the reputation of being an eccentric character who ate his own length in sausage on his wedding night. He also owned a liver-spotted pointer that was renowned locally for its ability to eat glass. (Courtesy of Joe Taylor.)

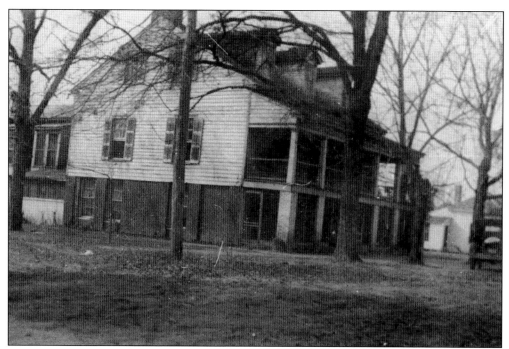

Dr. Hal Arrington, one of Livingston's first physicians, built this house. Following his death, the property was passed down to his niece, the wife of local judge Reuben Chapman. By the 1920s, it was being used as an apartment building. (Courtesy of Joe Taylor.)

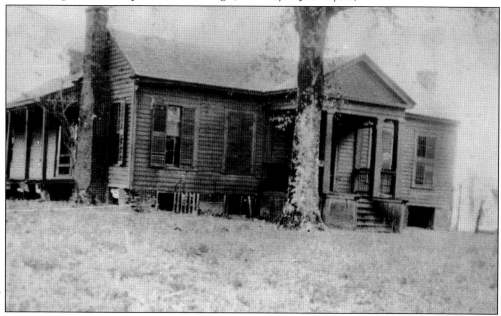

The home of J.W. "Jack" Harris was located next to the cotton warehouse. In addition to running the post office, Harris was a member of the Barrett Battery. Following his death, the house was purchased by William Bogg, a native of Ireland. Bogg was renowned for his tales as an orphan in Alabama in the days when the state was teeming with Indians and wild animals. (Courtesy of Joe Taylor.)

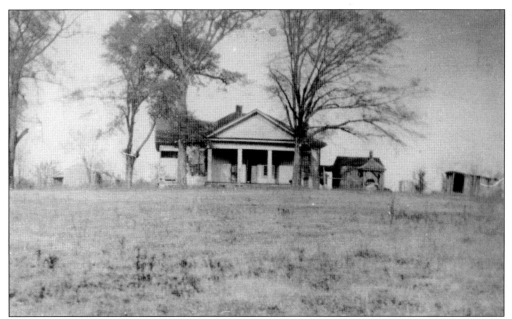

Another early settler in Livingston was H.W. Norville, a prominent businessman and one of the town's first mayors. He named his home Grampian after a line from John Home's tragedy *Douglas*. According to local legend, Dr. Davidson, a dentist, unsuccessfully tried to launch a flying machine from Norville's pasture. Davidson's mechanic broke his leg when the contraption crashed to the ground on its maiden flight. (Courtesy of Joe Taylor.)

After the abolition of slavery, a number of former slaves moved to Livingston. They lived in small pockets called quarters, such as Smith Flat, which stretched east from the home of Mrs. E.C. Vaughn to the railroad. A crooked thoroughfare called Tin Cup Alley ran through it. (Courtesy of Joe Taylor.)

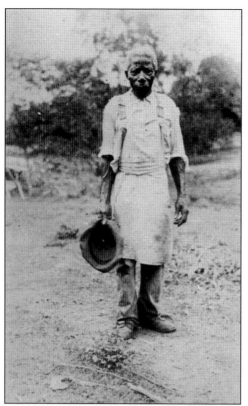

Walter Cook was one of the many former slaves who found work as servants in Livingston. Their responsibilities often included cooking meals, washing clothes, and cleaning guns, among other miscellaneous tasks. During the Civil War, Cook even went to war with his master. Walter Cook died in his mid-80s. He and his sister Lizzie Gray were well respected in both the black and white communities. (Courtesy of Joe Taylor.)

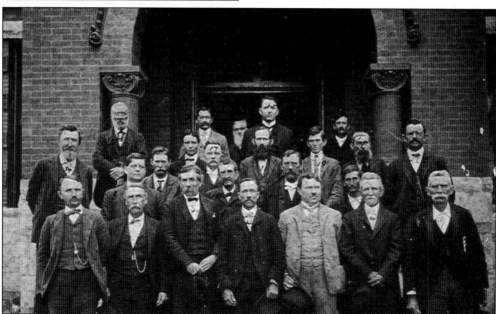

Grand juries investigate criminal misconduct and determine whether charges should be brought against the accused. This photograph, taken in 1903, depicts one of the first grand juries to convene in the Sumter County Courthouse after it was rebuilt in 1902. (Courtesy of the Center for the Study of the Black Belt.)

In 1800, Jeremiah Brown (right) was born in Darlington District, South Carolina. His father, Samuel Brown, was an English-born minister. Jeremiah attended South Carolina College and later studied law. However, managing a plantation held more appeal to him than practicing law, so Jeremiah became a planter. In 1835, he moved to a plantation outside of Sumterville and built his home, Louden (below), which is Sumter County's only Gothic Revival dwelling. In addition to his new wife, Julia, he brought 60 slaves with him. He was reputed to be a kindly master who gave his slaves Saturdays off and encouraged them to attend church. His holdings eventually increased to 1,000 slaves and 8,000 acres. A devout Methodist, Brown contributed $15,000 annually to missionaries. He also endowed the Brown Theological Chair at Howard College with $25,000. During the Civil War, he supplied enough provisions for an entire regiment. Jeremiah Brown died at the home of his daughter Mrs. H.S. Lide on February 10, 1868. (Courtesy of the Sumter County Historical Society).

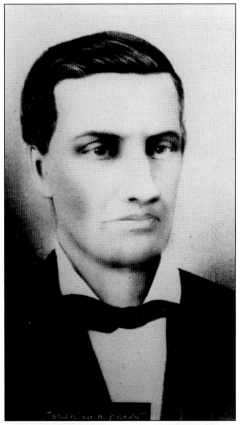

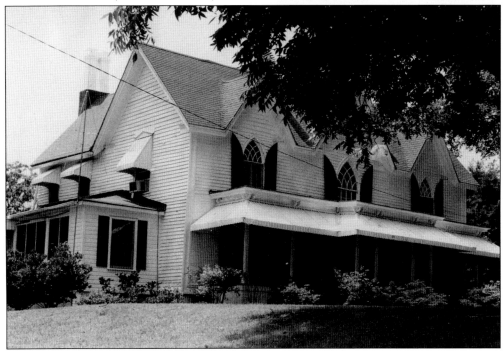

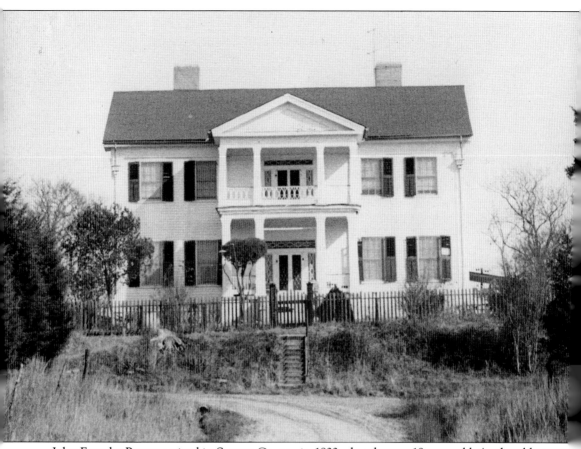

John Evander Brown arrived in Sumter County in 1833 when he was 18 years old. As the oldest of 10 children, he had to take care of his siblings and widowed mother. In 1848, he built this 13-room mansion, which he called the Cedars, in the modified Greek Revival style in Sumterville. Constructed of longleaf pine, it is said to have no knotholes in any of the boards. On the first floor was a prophet's chamber, where itinerant preachers spent the night. Brown lived at the Cedars with his wife, Mary Jane Godfrey Brown, until his death in 1878. (Courtesy of the Sumter County Historical Society.)

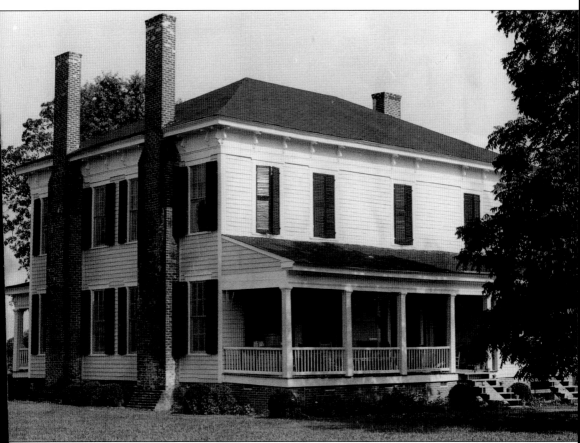

Oakhurst is one of three homes built by members of the Winston family; the other two properties are Oak Lawn and Oak Hill. Oakhurst was built in the Hamner-Sumterville area in 1854. The most prominent member of the Winston family, Gov. John A. Winston, is buried in Winston Cemetery, approximately a mile from the house. (Courtesy of the Sumter County Historical Society.)

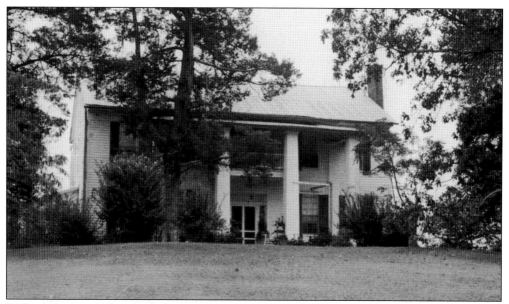

William Fierson Fulton built Farview in 1835. The house's heart pine attic beams were hand hewn, and the bricks were handmade on-site. All the locks, windows, and doors are original to the home and still functional. William named his property "Farview" because he could see as far as 12 miles from the freestanding balcony. The same family has owned the house ever since its construction. (Courtesy of Margaret Ramsay.)

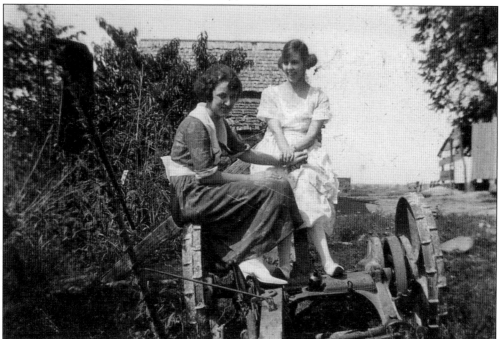

Mary Godfrey (left) and Alice Fulton Ramsay are pictured in front of the log cabin that William Fierson Fulton built as a residence for himself and his wife while the mansion was being constructed. After the Civil War, a freedman and his wife—Uncle Verge and Aunt Polly—lived in the old cabin. (Courtesy of Margaret Ramsay.)

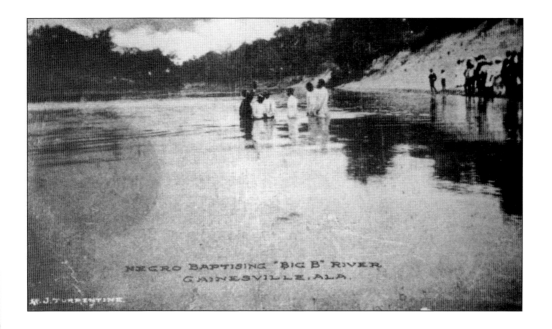

NEGRO BAPTISING "BIG B" RIVER
GAINESVILLE, ALA.

For generations, Africans Americans living in Sumter County were baptized in rivers and creeks, such as Jones Creek. In the ritual model followed by most African Americans living in the Deep South, the youngest candidates were baptized first. A deacon carrying a stick walked into the river first to make sure that the water was not too deep or boggy. The preacher escorted the candidates into the water one at a time and folded their hands. While immersing the candidates in the water, the preacher recited a prayer: "I baptize this brother [or sister] in the name of the Father, the Son, and the Holy Ghost on the basis of their faith." When the candidate rose from the water, the members embraced and covered him or her with a sheet. Then, as the group sang baptismal songs like "Take Me to the Water," the candidate was allowed to change clothes, sometimes behind a sheet draped from a tree branch. As a rule, the preacher delivered a short sermon between baptisms. (Both, courtesy of the Julia Tutwiler Library.)

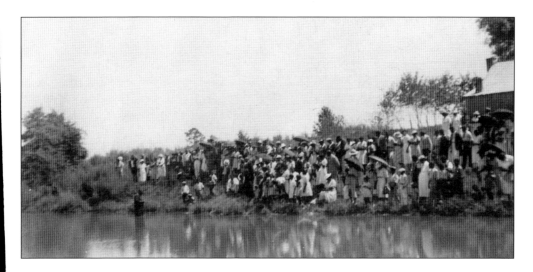

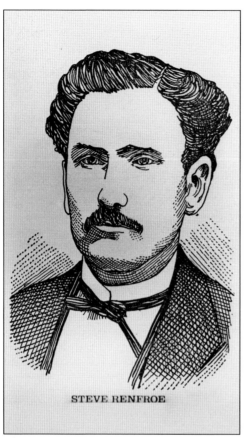

STEVE RENFROE

In 1868, Steve Renfroe (left), whose image appeared in the *Montgomery Daily Dispatch* on October 10, 1886, arrived in Livingston from Lowndes County. Renfroe built his home (below) on Jefferson Street in the 1870s. He soon rose to prominence in the community because of his hatred of blacks and carpetbaggers. Through his wife's family connections, he joined the Ku Klux Klan. A few months later, he murdered two black men—Caesar Davis and Frank Sledge—near the old iron bridge at Boyd. Following his acquittal for the murder of a carpetbagger named Billings in 1874, he was elected sheriff of Sumter County in 1876. Not long thereafter, he was incarcerated for embezzling county funds. Renfroe escaped and was captured several times before establishing a hideout in the Flatwoods between Livingston and the Mississippi border. He robbed private homes in Livingston until he was apprehended by three farmers in Enterprise, Mississippi, and returned to the Livingston jail. On July 13, 1886, a group of men removed him from jail and lynched him from a chinaberry tree along the Sucarnochee River. The identities of the members of the lynch mob have never been revealed. (Both, courtesy of the Sumter County Historical Society.)

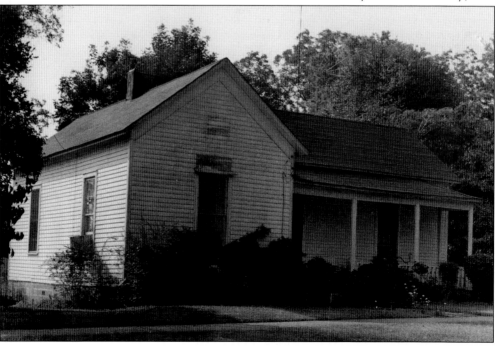

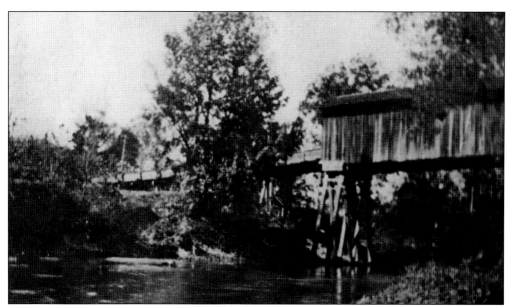

Designed by architect Ithiel Town, the Alamuchee-Bellamy Bridge was constructed under the orders of Confederate army captain W.A.C. Jones in 1861. The lattice truss bridge was originally located on the main state road (now US Route 11) connecting Livingston and York. In 1924, the bridge was relocated five miles away, to the old Bellamy-Livingston Road. The covered bridge was restored and moved to the Livingston University campus in December 1969. (Courtesy of the Sumter County Historical Society.)

The Choctaw Tavern was built between 1832 and 1833 in the shape of an L that extended down Marshall Street. The building housed a number of commercial spaces known as the Offices of the Choctaw. After the tavern was torn down in 1930, the Methodist church rebuilt it at Madison Street. In 1999, the Choctaw Tavern was moved to the University of West Alabama campus. (Courtesy of the Sumter County Historical Society.)

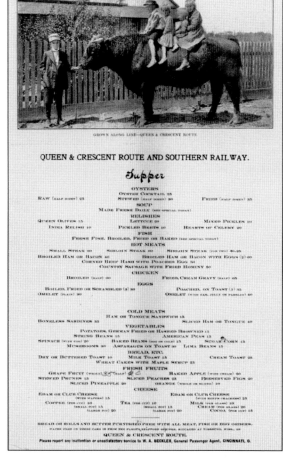

Robert Ezekiel Campbell and his wife, Susan Alice Gully, operated a general store in Whitfield, Alabama. In 1900, he built a double-dogtrot house within walking distance from his store. It was home to the Campbells and their 11 children, as well as a local schoolteacher. (Courtesy of the Center for the Study of the Black Belt.)

The Campbells' five daughters were Alice, Laura, Betty, Justina, and Sarah; their three sons were Slocum, Wayne, and Bob. Because they were living in a rural area, the children had a number of animals as pets. A photograph of the Campbell children sitting on the back of a bull was used on a menu for the Queen & Crescent Route and Southern Railway. (Courtesy of the Center for the Study of the Black Belt.)

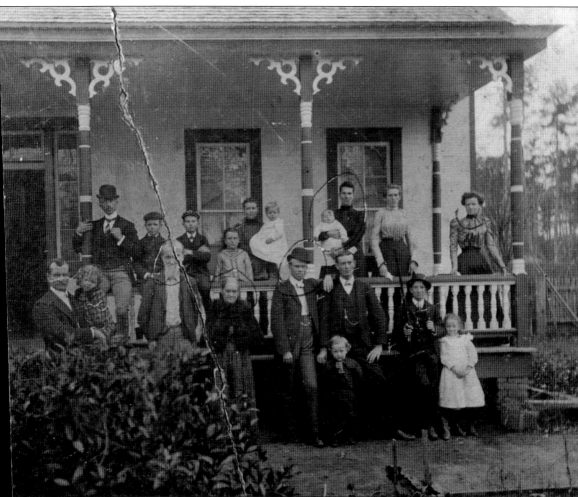

James Charles "Jimmie" Rodgers, known as "the Father of Country Music," was born on September 8, 1897. While Meridian, Mississippi, is commonly known as his birthplace, Rodgers signed documents later in life indicating that he was born in Geiger, Alabama, where his father's parents lived. The controversy over his actual birthplace may never be resolved even though some insist that he was born in Pinefield, Mississippi, just northwest of Meridian. The fact remains that after his mother died when he was six or seven years old, Rodgers lived with relatives near Geiger and in other small towns in southwestern Alabama and southeastern Mississippi. When Rodgers was 10, he went to live with his father and his stepmother in Meridian. At age 13, Rodgers began working on the railroad with his father as a water boy. His primary interest, though, was the songs he heard from hoboes and African American gandy dancers (track layers and maintenance workers). He eventually became a brakeman on the New Orleans & Northeastern Railroad, but his career was cut short in 1927 when he contracted tuberculosis. Rodgers immediately embarked on his second career—professional musician. He continued to play and record until May 26, 1933, when he died from a pulmonary hemorrhage. Pictured here is his mother's family, the Bozemans. Eliza (Bozeman) Rodgers, to right of the center post, is holding her son Jimmie. (Courtesy of the Jimmie Rodgers Museum.)

Longtime Sumter County leader John Hendrix Pinson was born on January 15, 1876. The founder of Geiger was educated in county schools before attending Fairview College in Mississippi and Southern Business University in Atlanta, Georgia. He was elected to the Alabama House of Representatives from 1947 to 1951 and to the Alabama State Senate from 1943 to 1947 and again from 1951 to 1953. When he was not involved in politics, Pinson worked as a cattleman, farmer, and merchant. He died in Mobile, Alabama, on October 12, 1969. (Courtesy of Freda Brown.)

John H. Pinson married Birdie Augusta Geiger in 1901. She was related to one of the Geigers, William M. Geiger, who first settled the area in the mid-1800s. Birdie and her husband had one son, Geiger Pinson. Birdie was killed in a car wreck on Highway 16. (Courtesy of Freda Brown.)

The town of Geiger, Alabama, was the brainchild of two entrepreneurs—John H. Pinson and W.L. Waller. They came up with the idea of creating a town after the Alabama, Tennessee & Northern Railroad (AT&N) came to the area in 1909. One of their most daring promotions was the drawing for free lots and farms. Not surprisingly, the town began to flourish. One of the original buildings was the bank, constructed in 1912. The bank, which was owned by Waller, closed in 1917, primarily as a result of the boll weevil infestation. Because most of the cotton farmers moved away, Geiger never fully recovered. In the 1950s, brick from the second story of the bank was used to veneer a house in Mobile. (Courtesy of the Sumter County Historical Society.)

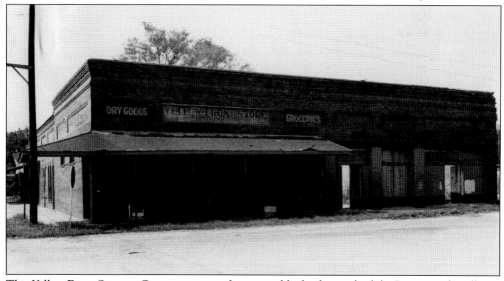

This Yellow Front Store in Geiger was part of an entire block of stores built by Pinson and Waller in 1911. It was similar to a modern strip mall in that it housed a number of small businesses. A chain of Yellow Front stores developed with locations all across Alabama. (Courtesy of Freda Brown.)

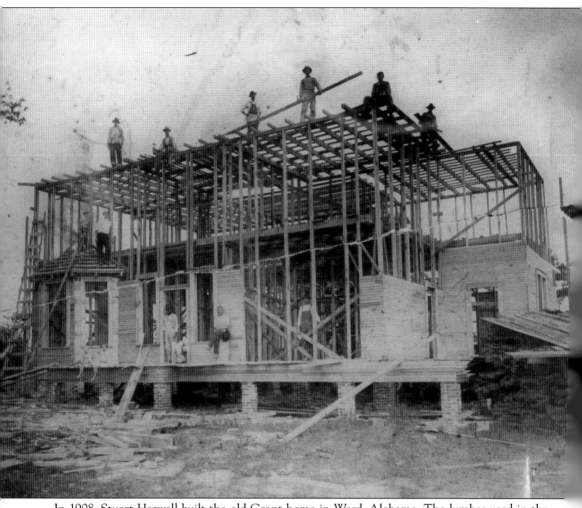

In 1908, Stuart Harwell built the old Grant home in Ward, Alabama. The lumber used in the construction of the house came from the Allison Lumber Company in Bellamy. By 1928, the Allison Lumber Company was manufacturing 110,000 board feet of lumber per 21-hour day. The mill cut pine lumber by day and hardwood lumber by night. The two-truck Shay locomotives of the Sumter & Choctaw Railway (S&C) hauled lumber and worked the spur tracks, driving the loaded cars of logs out to the main line. By 1930, old-fashioned spur logging had been discontinued in Alabama. (Courtesy of the Ward, Alabama Museum.)

In 1909, L.S. Grant purchased Harwell's home, which is right across the road from the Old Grant Store. Several generations of the Grant family lived in the home until it was purchased by Timothy Edward Rew, who resided there for several years before turning it over to his mother, Corrie. With the assistance of several individuals from the community, she assembled a collection of memorabilia from Ward's past. The house turned museum features furnishings from the old post office, which was built in the 1940s. (Courtesy of the Ward, Alabama Museum.)

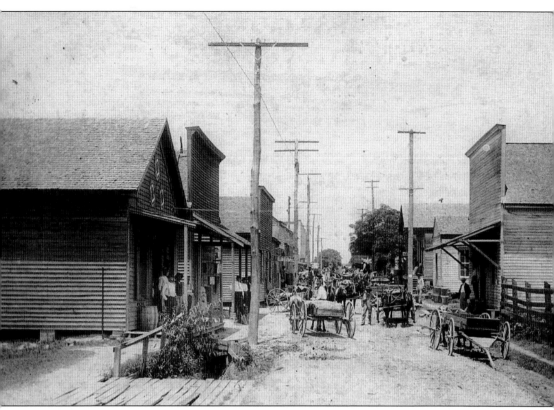

The founder of Cuba, Alabama, was R.A. Clay, who moved to Sumter County from Autauga, Alabama, with 100 slaves in 1852. He bought all the land that makes up present-day Cuba. By 1900, Cuba was a bustling farm town with a mercantile, livery stable, newspaper, hotel, pottery plant, and cemetery. This photograph, taken in the early 1900s, depicts a view of Chicken Street, which is now Third Street between Third and Fourth Avenues. (Courtesy of the Cuba Museum.)

Two

SCHOOL DAYS

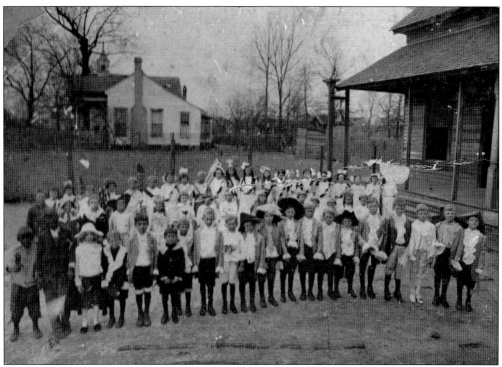

One-room schoolhouses were commonplace in the United States in the late 19th and early 20th centuries. As late as 1913, nearly half of the country's 2,000 schools were one room. The number declined after World War I as schools began to consolidate. The number of students attending each school depended on the population of the area. Some of these simple frame structures had a cupola with a school bell. Before the advent of slate chalkboards, children wrote on individual slates. Many teachers had attended the schools where they taught and were expected to arrive early to warm up the classroom. Sometimes teachers cooked noon meals for the students. The wood or coal for the stove was brought in by the older students, while the younger students cleaned the chalkboards and erasers. In many communities, the one-room schoolhouse was also used for picnics and town meetings. As a rule, teachers lived close to the schoolhouse or boarded with local families. By World War II, most one-room schoolhouses had been replaced by larger facilities, with the exception of those in rural areas. Cuba received its first state money for education in 1880, but the costs were also subsidized by tuition. The one-room schoolhouse in this 1906 photograph was the first public school in Cuba, with Eugene Shaw as the first teacher. It stood on what is now the site of the Holiness Church. (Courtesy of the Cuba Museum.)

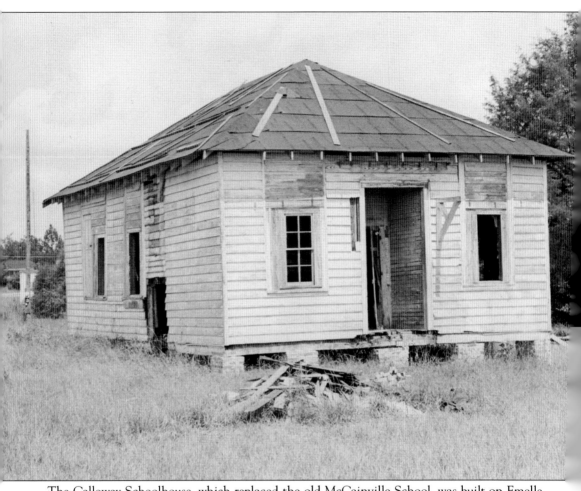

The Calloway Schoolhouse, which replaced the old McCainville School, was built on Emelle Livingston Road on land donated by Condee Boyd. It was named after former Sumter County superintendent R.B. Calloway, who taught two generations of students at the McCainville School. The Calloway Schoolhouse had only one door and two blackboards, and it was heated by a potbellied stove. The school closed in 1927 as a result of consolidation. For the next 50 years, the old schoolhouse served as a private residence, with the large classroom divided into several rooms. Ernest Boyd, who started first grade at the school in 1918, donated it to Livingston University. (Courtesy of the Sumter County Historical Society.)

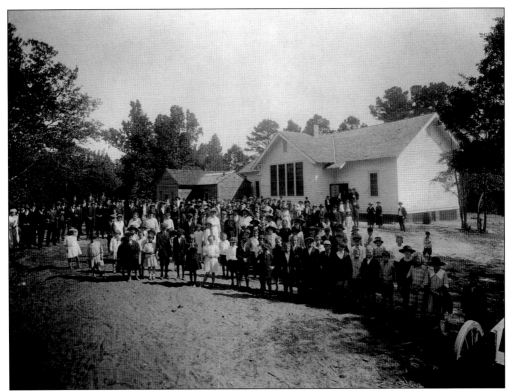

On the back of this photograph from the F.I. Derby Collection is the following inscription: "All of the Derby children attended Shelbyville School." The entire student body is gathered in front of the new school building, along with parents and other local citizens standing behind them. Annie Lee was the teacher at this time. (Courtesy of the Center for Study of the Black Belt.)

Cuba Elementary School was built between 1900 and 1907. It remained in constant use until the 1970s, when it closed. Until the old school burned on October 15, 1995, children played basketball in the gym. Longtime Cuba resident David Hatcher said that the ceiling was so low that the players were unable to shoot very high. (Courtesy of the Black Belt Museum.)

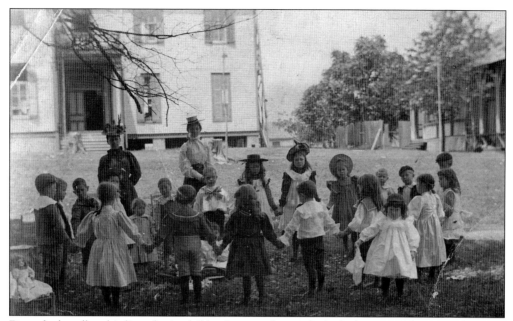

Drop the handkerchief is a classic children's game akin to duck, duck, goose. Those standing in a circle wait for the one holding the handkerchief to drop it behind a randomly selected opponent. When it is dropped, that child breaks hold and tries to tag the other before he or she can reach the vacated space in the circle. Here, Livingston kindergarten students play drop the handkerchief in the early 1900s. (Courtesy of the Julia Tutwiler Library.)

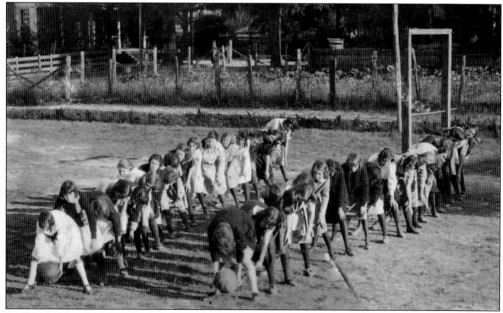

In this 1920s photograph, female students at Cuba High School are playing handball during recess. The two teams of girls are passing the ball between their legs. As soon as a player passes the ball, she runs to the end of the line. The team that moves its last player to the front of the line first is considered the winner. When handball is played indoors, the game ends when one of the teams reaches the opposite wall. (Courtesy of the Black Belt Museum.)

John Hendrix Penson built this high school in Geiger in 1910. It was the first public school in Sumter County to offer free public transportation and the first consolidated school in the state. For many years, the auditorium was the venue for traveling performers. After the school closed, it was taken over by a home demonstration club called the Yakity-Yak Club. It still meets at the old school once a month. (Courtesy of the Sumter County Historical Society.)

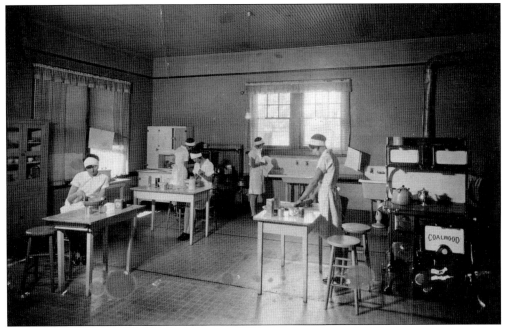

Since its creation by Cynthia Beecher and Ellen Richards in the mid-1800s, home economics has prepared young people for the task of running an efficient household. In this 1920s photograph, high school girls are baking during home economics class, which was taught in an old house next to the high school in Cuba. (Courtesy of the Cuba Museum.)

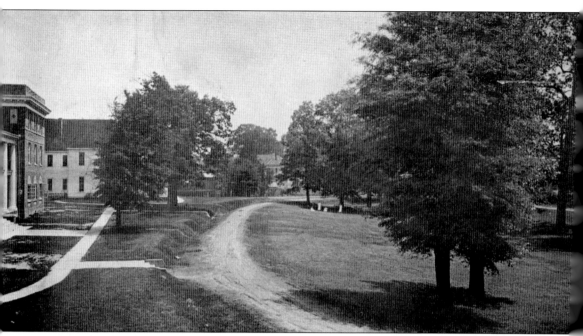

By the time this photograph of the campus was taken in 1920, the University of West Alabama had been in existence for 85 years. The church-supported school was established in 1835 under the name Livingston Female Academy. The institution was incorporated by the state legislature on January 15, 1840. In exchange for losing its independence, the school was granted tax-exempt status. Newspapers referred to the institution by a variety of names in the early years, including Livingston Academy, Livingston Female Academy, Livingston Female Seminary, and Livingston College. (Courtesy of the Julia Tutwiler Library.)

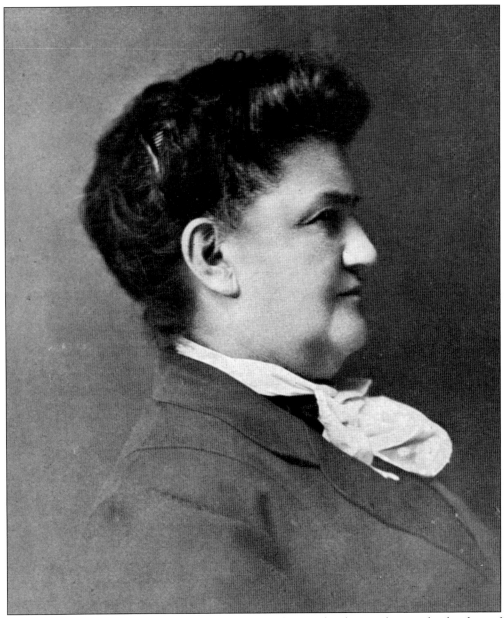

Born in Tuscaloosa, Alabama, on August 15, 1841, Julia Strudwick Tutwiler was the daughter of Henry Tutwiler, the founder of the Greene Springs School. After completing her education at Vassar College, Washington and Lee University, and various schools in Germany and France, Tutwiler became the best educated woman of her time. She taught at her father's school, Greensboro Academy, and at Greene Springs before her appointment in 1881 as coprincipal of the Livingston Female Academy. As the first president of Livingston State Normal School in 1890, Tutwiler promoted the progressive methods for teaching girls and young women that she had learned in Germany, such as educational games and handicrafts. She was remembered by alumni as a generous person who loaned money to students in need and used her own funds to maintain the residential cottages. Upon her retirement in 1910, Tutwiler was named the first professor emeritus in Alabama. (Courtesy of the Julia Tutwiler Library.)

During Tutwiler's administration, the college offered Bible instruction and religious exercises. At the 1892 commencement, scripture readings by students replaced the sermon. All students were required to attend church on Sunday. Not surprisingly, a number of students at Alabama Normal College became missionaries. In this 1907 photograph, Tutwiler (right) is sitting on the lawn in front of Webb Hall with Elisa Cortez, a student from Mexico who went on to become a missionary. (Courtesy of the Julia Tutwiler Library.)

In the 1880s and 1890s, Commencement Week began on Sunday with a commencement sermon. Concerts, recitations, and an operetta were held on Tuesday. A special concert and the annual reception took place on Wednesday. Commencement Week ended on Thursday with graduation exercises. Displays from the art department and the vocational department were featured during this week. In this commencement photograph, Julia Tutwiler is the seated figure in the black dress. Surrounding her on the dais are teachers from the various departments. (Courtesy of the Julia Tutwiler Library.)

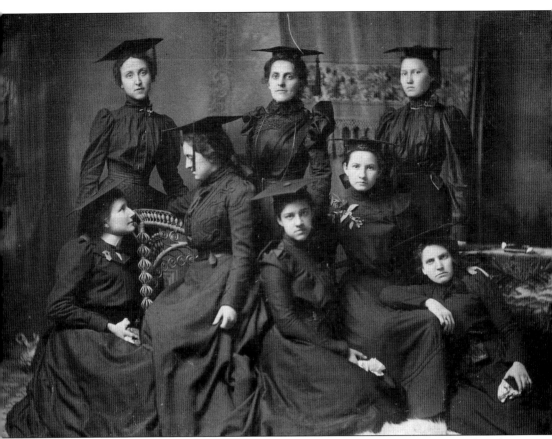

In 1892, Julia Tutwiler informed the trustees of the University of Alabama (UA) that even though the federal government had earmarked funds for educating all the young people in the state, half of the population—women—were not being educated. Thanks to Tutwiler's tireless efforts, the first female students matriculated at UA in 1893. Spurred by the success of female students who were attending UA, Tutwiler informed the trustees that 10 female students from Alabama Normal College were interested in attending UA, provided that arrangements could be made for housing. The university accepted the 10 students and designated Harris Hall as a women's dormitory; the president then renamed the building the Julia Tutwiler Annex. The chaperon at the annex was one of Tutwiler's former students. During the commencement exercises of 1900, four of the six highest honors were awarded to students who had transferred from Alabama Normal College. The eight students who posed for this photograph are, from left to right, (first row) Fannie Ingersoll, Alma Bishop, Sadie Mason, Lelia McMahon, and Mamie Bullock; (second row) Mary De Bardeleben, Anne Turk, and Kate Horn. Not pictured are Augusta Clearly and Rosa Lawhorn. (Courtesy of the Julia Tutwiler Library.)

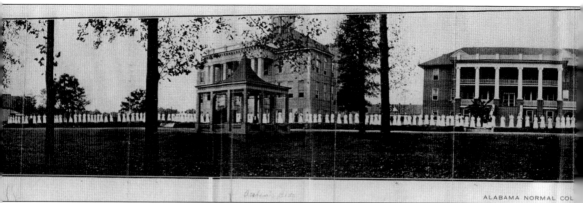

This panoramic view of the students at Alabama Normal College was taken before Julia Tutwiler's retirement in 1910. The buildings pictured are, from left to right, Tutwiler Hall, Webb Hall, and Jones Hall. Tutwiler required her students to wear seasonal uniforms because she believed that "a uniform promotes economy and saves time and thought." The summer uniform, which the women are wearing in the photograph, consisted of white mull dresses trimmed with ruffles and

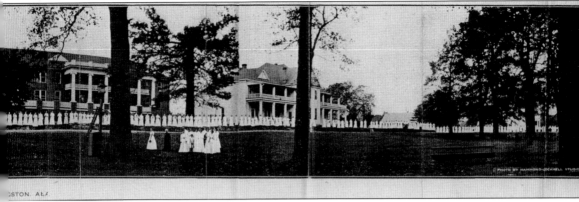

puffed sleeves. A plain straw hat and black lace mitts completed the uniform. Plain white dresses, without embroidery or lace except for the neck and sleeves, were the public dress for Commencement Week exercises. For winter, students were required to wear a black cashmere dress and a wrap or plain black cloak of the same material. (Courtesy of the Julia Tutwiler Library.)

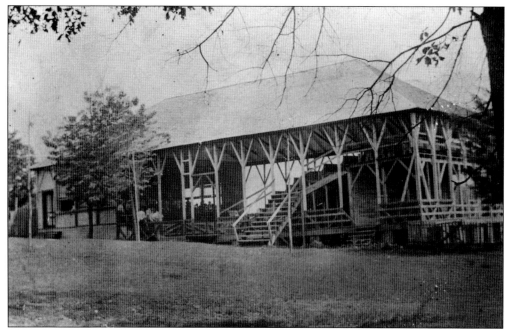

This barnlike building was called the Pavilion. Located where Brock Hall now stands, this structure, which was open on three sides, served as the auditorium. A stage and dressing rooms occupied part of the Pavilion. The remainder of the Pavilion was used as classrooms. Students sat on wooden benches and bleachers that reached to the ceiling. (Courtesy of the Julia Tutwiler Library.)

One of Livingston's most prominent citizens in the late 19th century was Dr. R.D. Webb, who came to town in 1853. He served as president of the state's medical association and as a member of the board of trustees of Alabama Normal College for 40 years. He was a medical researcher who published an article on malaria for the state medical journal. Webb also treated the students, one of whom referred to him in a scrapbook as "Our Doctor." (Courtesy of the Julia Tutwiler Library.)

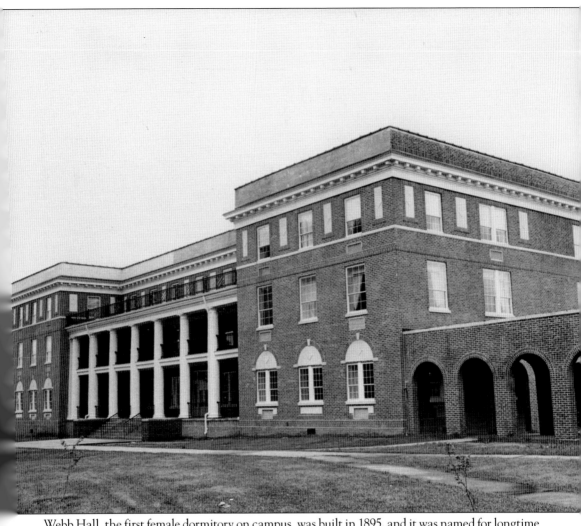

Webb Hall, the first female dormitory on campus, was built in 1895, and it was named for longtime board member Dr. R.D. Webb. In addition to bedrooms, the dormitory contained a kitchen and dining room. On April 3, 1909, the first Webb Hall burned down. Damages were estimated at $10,000. However, only $5,700 was covered by insurance. The residents of Webb Hall lost all their possessions in the fire, so the town of Livingston raised $200 to buy new clothes, books, and school supplies for the destitute students. A number of local families even allowed students to stay with them until more permanent housing could be found. The April 14, 1909, issue of *Our Southern Home* published a letter from the college thanking the community for reaching out to the students in their hour of need. Webb Hall was rebuilt in 1911 with funds raised through the sale of interest-bearing bonds issued by the college. The second Webb Hall burned down in 1914 and was rebuilt one year later. (Courtesy of the Julia Tutwiler Library.)

Around 1900, students boarded at Webb Hall dormitory and at eight cottages owned by Julia Tutwiler. Approximately half of the students at this time lived in the cottages. One of these residences, Morrow Cottage, is seen in the photograph at left. Below is Mrs. Wright, one of the matrons who supervised the young women in the cottages. In 1908, Tutwiler donated her eight cottages to the college. (Both, courtesy of the Julia Tutwiler Library.)

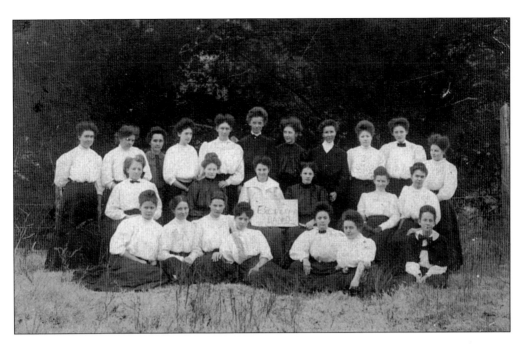

Julia Tutwiler believed that her students should be educated in cultural studies as well as in the professions. Students were required to read and analyze the works of classic British writers such as William Shakespeare. They were encouraged to take classes in drawing and painting to give them the skills needed to, as one catalog put it, "make their homes beautiful and attractive." Vocal and instrumental music were also an important part of the curriculum during Tutwiler's administration. The 1907 photograph above depicts members of the Excelsior Band, including Mollie Thomas, Lena Bennett, Leila Grace Thomas, Velma Tucker, and their instructor, Miss Nordbuah. Seen below in the early 1900s is a crowded modeling class, which famed sculptor Geneva Mercer took during her stay here. (Both, courtesy of the Julia Tutwiler Library.)

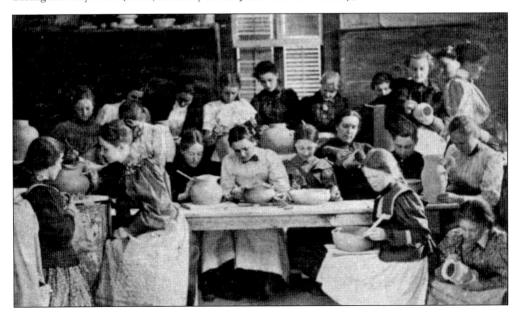

Prior to becoming Julia Tutwiler's successor as president in 1910, Dr. George William Brock had been employed at Alabama Normal College as business manager since 1907. Brock was instrumental in converting the college into a teacher-training institution. During the Brock years, the campus expanded from 4 acres to 35 acres. He was responsible for the construction of Bibb Graves Hall, Brock Hall, and Foust Hall, designed to resemble a modern school building. Under Dr. Brock, the Olmstead Brothers architectural firm was hired to plan the school grounds. At the time of his retirement in 1936, enrollment was 500 students. (Courtesy of the Julia Tutwiler Library.)

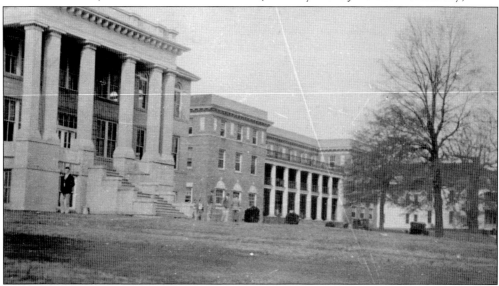

This impressive three-story building was constructed in 1907 with $20,000 worth of bonds issued by the town council. The brick and stucco building had 21 classrooms, an auditorium, and a gymnasium. Dr. G.W. Brock, who became Tutwiler's successor in 1910, applied for aid from the Peabody Fund to complete the third story. In 1915, it was christened Julia Tutwiler Hall in honor of the former president. (Courtesy of the Julia Tutwiler Library.)

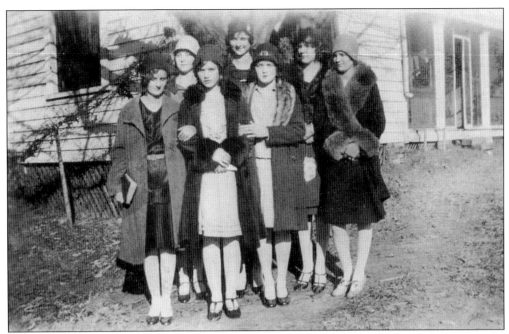

Although students were no longer required to attend church on Sundays during Dr. Brock's administration, many of them continued the practice on their own. Pictured above outside one of the student cottages, several coeds pose in their Sunday best, according to the fashion standards of 1928. After church, students in the dorms were encouraged to relax and study. The scrapbook caption for the photograph below reads, "After Hours, Sunday Afternoon." (Both, courtesy of the Julia Tutwiler Library.)

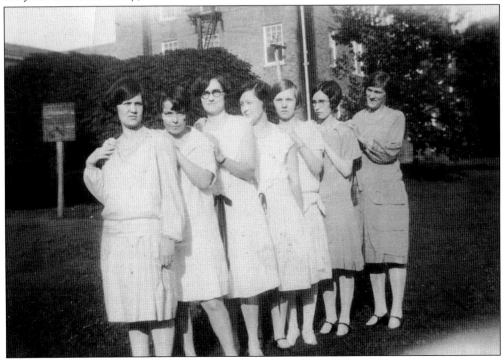

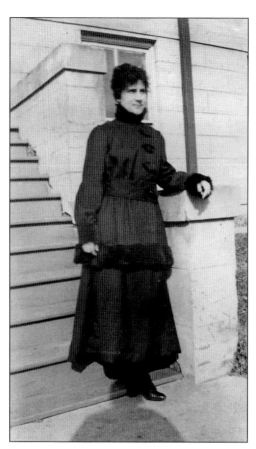

Ettie Knight, from Healing Springs, Alabama, attended Alabama Normal College in the years before World War I. Dressed in the style of 1916, she is seen at left on the steps of Tutwiler Hall. Below, she is pictured on graduation day, May 18, 1916. (Both, courtesy of the Julia Tutwiler Library.)

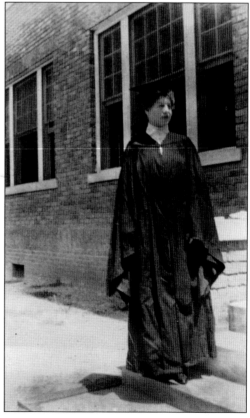

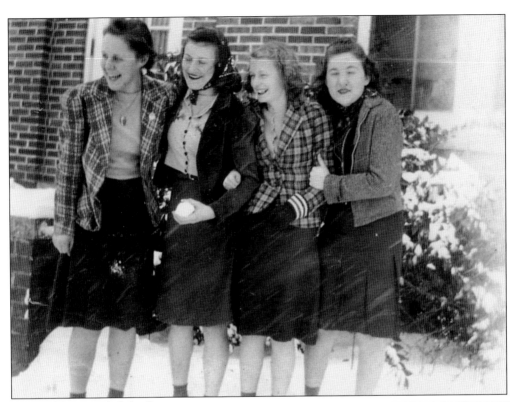

Julia Wilder attended the State Teachers College in the early 1940s, during the administration of Dr. Noble Greenhill. In this photograph taken from her scrapbook, she and her friends are frolicking in the snow outside Webb Hall on February 9, 1940. From left to right are Julia Wilder, Mary Emma Speed, Virginia Johnson, and Eugenia Garrison. Snow is so rare in the South that, even today, it creates quite a fervor among students enrolled at the University of West Alabama. (Courtesy of the Julia Tutwiler Library.)

Mary Ward Brock was hired as a teacher of elocution in 1929. Her job was to instruct students in the proper use of pronunciation, grammar, tone, and style in formal speech. After becoming Dr. Brock's second wife, Mary became a librarian at the college. (Courtesy of the Julia Tutwiler Library.)

The L Club, which came into existence before World War II, consisted of athletes who had lettered in any campus sport. Over the years, members raised money to support organizations like the American Cancer Society and to purchase their letterman sweaters, which they wore until the 1970s. According to R.T. Floyd, president in the late 1970s and sponsor in the 1980s, the L Club held the first sports banquet on campus. Guest speakers included such notables as Heisman Trophy winner Pat Sullivan from Auburn University. The L Club was eventually phased out in the 1990s as a result of coaching and personnel changes. (Courtesy of the Julia Tutwiler Library.)

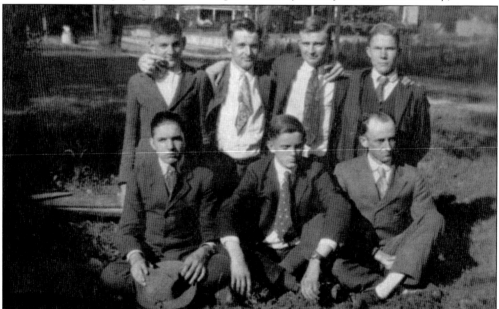

In 1911, Brock revoked the coeducational feature of Alabama Normal College that had been in place since the 1900–1901 school year. Those close to Brock said that he opposed coeducation because he disliked boys. Even though the school became coeducational once again in 1915, the number of males who attended the college remained small during his administration, possibly because the college's primary emphasis was the training of elementary school teachers, most of whom were female. In 1918, these were the only male students in the entire college. (Courtesy of the Julia Tutwiler Library.)

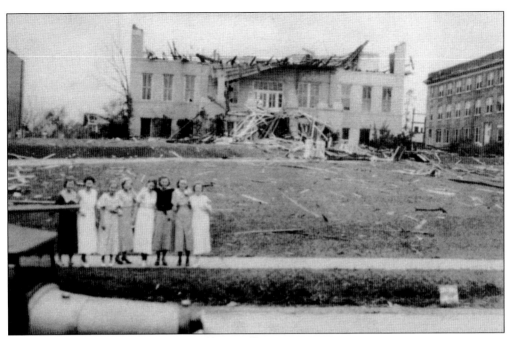

In 1934, the top floor of Tutwiler was blown off in a tornado. The first and second floors continued to be used as the bookstore, art department, cafeteria, and post office for several decades. The building was razed in 1977. The original cornerstone is on display outside of Webb Hall. (Courtesy of the Julia Tutwiler Library.)

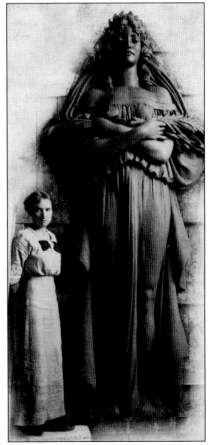

One of Julia Tutwiler's most famous students was sculptor Geneva Mercer, born on January 27, 1889, in Jefferson, Alabama. After graduating from high school, Mercer attended the Alabama Normal College in Livingston. Julia Tutwiler hired an art teacher from Chicago, Illinois, to give Mercer art lessons. From 1909 to 1927, she worked with Giuseppe Moretti in Pittsburgh, Pennsylvania; Florence, Italy; and Havana, Cuba. In this photograph, taken in the early 1900s, Mercer is standing next to one of the figures in the Centro Gallego, commissioned in Italy. (Courtesy of the Julia Tutwiler Library.)

For over three decades, James P. "Dean" Homer was a beloved coach and administrator at Livingston University. He played college basketball for the University of Alabama, then went on to play professional basketball for the Syracuse Nationals in New York until he was sidelined by a back injury. Dean Homer, as he was affectionately known, was hired as a coach in 1949. In addition to coaching basketball, football, and baseball, Dean Homer served as athletic director, dean of men, dean of students, and executive vice president before retiring in 1984. (Courtesy of the Julia Tutwiler Library.)

Born in Brandon, Mississippi, on February 17, 1939, Mary Ann Mobley became the first Miss Mississippi to win the title of Miss America 1959. Following her victory in September 1958, Dr. D.G. Harris, a professor of psychology, invited Mobley to crown the next homecoming queen of Livingston University. She arrived on campus on November 1, 1958, and was welcomed by Faye Harry Bedwell and Wilma Vick Brown. (Courtesy of the Julia Tutwiler Library)

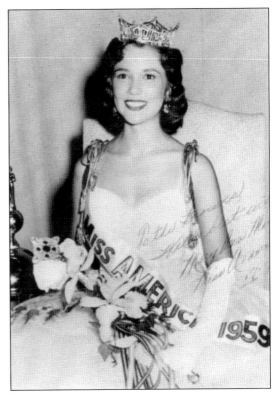

Although the government had forced Gov. George Wallace to allow black students to enroll at the University of Alabama, Livingston University remained segregated for another three years. Then, in 1966, Liza Howard became the first black student to be admitted to Livingston University. After graduating in 1969, she went on to earn a master's degree in education from the university. (Courtesy of the Julia Tutwiler Library.)

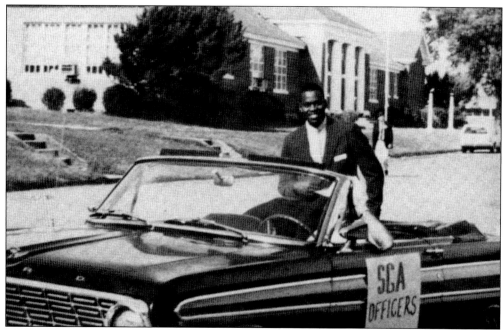

Livingston University did not have a black Student Government Association (SGA) president until 1985, when Bobby Warren was elected. He is seen here during the 1985 homecoming parade. The SGA has had a number of black presidents since then. (Courtesy of the Julia Tutwiler Library.)

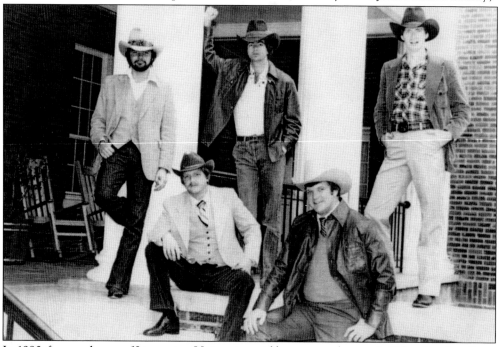

In 1980, five employees of Livingston University paid homage to the movie *Urban Cowboy*. From left to right are (first row) Lawson Edmonds and Al Mitchell; (second row) Danny Buckalew, Billy Watt, and Bruce Sims. Buckalew, Mitchell, and Sims had just graduated from Livingston University when this photograph was taken. (Courtesy of the Julia Tutwiler Library.)

Three

RUBY PICKENS TARTT

Ruby Pickens Tartt was born to William King Pickens and Fannie West Short Pickens on January 13, 1880. Her older brother was Champ Pickens. Ruby's father, a well-to-do cotton grower, often took her to the cotton fields, where she enjoyed hearing the stories and songs of the field hands. Ruby attended Livingston Female Academy and Alabama State Normal College. Her mentor was progressive educator Julia Tutwiler. Later, she studied art under William Merritt Chase at the Chase School of Art in New York. Chase had a tremendous influence on her painting style, and Ruby went on to teach art in Livingston. On October 18, 1904, Ruby married Pratt Tartt, who worked at his family's bank. Their only child, Fannie Pickens Tartt Ingliss, went on to become an accomplished artist in her own right. (Courtesy of the Center for the Study of the Black Belt.)

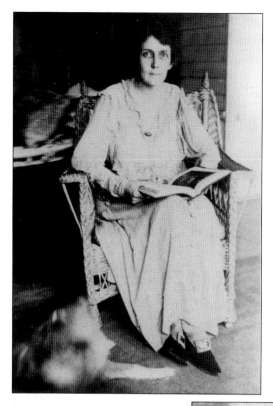

During the 1920s, Ruby assisted Carl Carmer, an English professor from the University of Alabama, with a collection of Alabama folklore titled *Stars Fell from Alabama*. As a field worker for the Works Progress Administration, she compiled slave narratives and African American folklore through interviews she conducted in 1937–1938. In the late 1930s and early 1940s, she assisted ethnomusicologist John Lomax with the recording of hundreds of folk songs in Sumter County. (Courtesy of the Center for the Study of the Black Belt.)

Texan John Lomax (left) achieved notoriety as America's greatest folk song collector following the publication of *Cowboy Songs and Other Frontier Ballads* in 1910. In 1934, Lomax was appointed honorary consultant and curator of the American Archive of Folk Song. Richard Brown (right) worked as a farmer on an old plantation in Sumterville. Even though Brown was not a religious man, most of the songs he sang for John Lomax in 1940 were spirituals. (Courtesy of the Library of Congress.)

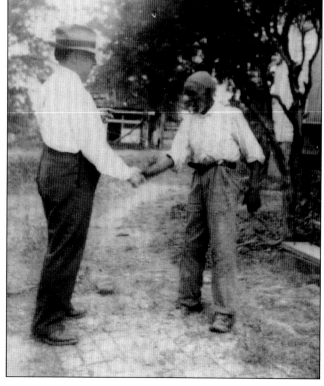

Richard Manuel "Rich" Amerson was born in 1892 on a farm in Brown's Chapel, not far from Sumterville. His father, Spencer, was literate, but his mother, Rose, was not. Amerson had four siblings. He was a free spirit who eked out a living doing odd jobs, such as digging wells and picking strawberries. John Lomax referred to Rich as "the prize find of all my journeyings." When John Lomax interviewed Amerson, he sang the blues, spirituals, and ring game songs. Lomax's personal favorite of all Rich Amerson's songs was the bluesy "Black Woman." (Courtesy of Nat Reed.)

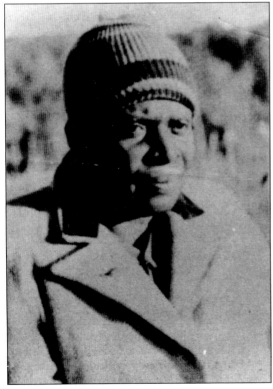

Earthy Ann Coleman, Rich Amerson's sister, was born in 1889. She told Ruby Pickens Tartt that she was given her name because "I was a long time growin' up from the earth." She named one of her children "ForeDay" because he was born just before sunup. Although Earthy Ann usually sang alone, she also sang with Rich Amerson and Price Coleman. Her recorded songs include "Rock, Chariot," "It's Gettin' Late in the Evenin'," "Job, Job," "Didn't You Hear?" and "Give My Heart Ease." (Courtesy of the Julia Tutwiler Library.)

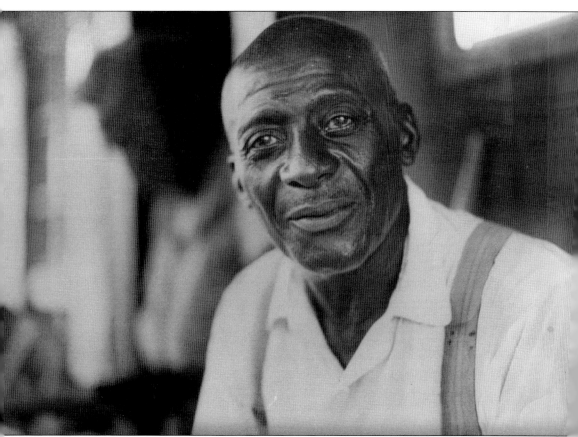

In 1898, Dock Reed was born in Sumter County. His parents christened him Zebediah, but he went by Dock his entire life. He and his wife, Hattie, raised his sister's two orphaned children. Reed was a farmer, cedar fence post cutter, molasses maker, and preacher. He was a deeply religious man who sang only spirituals, occasionally with Vera Hall. Dock was often called upon to lead the singing of hymns in area churches. John Lomax hailed Dock Reed as his favorite of all the Sumter County singers. Reed was also close to Ruby Pickens Tartt, who gave him money when his leg was amputated in 1944. With tears streaming down his face, Reed sang "Steal Away" at her funeral. Dock Reed's recorded songs include "Amazing Grace," "Rock, Chariot," "Job, Job," "Death Is Awful," "He's Gone but He's Comin'," "Everywhere I Go, Somebody's Talkin' 'Bout Jesus," "Climbin' up the Hill of Mount Zion," and "Certainly, Lord." (Photograph by Jo Tartt; courtesy of the Julia Tutwiler Library.)

Vera Hall was born in 1902 on small farm just outside Livingston. She developed her love of folk music by listening to the songs of Rich Amerson and Blind Jesse Harris, two folk singers from Livingston. For most of her life, Vera worked as a domestic servant in Livingston and Tuscaloosa until she lost her sight. In the 1940s, her songs were used in a BBC documentary on American folk music. Her song "Another Man Done Gone" was played during the 75th anniversary of the signing of the Emancipation Proclamation. This image is from the monument in Livingston's town square. (Photograph by author.)

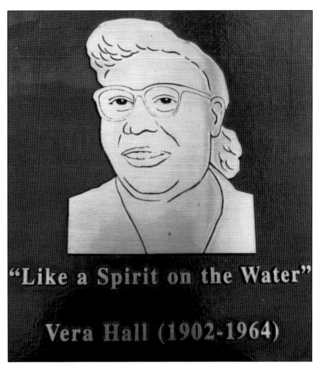

"Like a Spirit on the Water"

Vera Hall (1902-1964)

Josh Horn was born in 1854 on Horn Plantation in Brewersville. He and his wife, Alice, had been childhood playmates. The couple married in 1877 and had 16 children. Horn was known throughout Sumter County as an expert hunting guide and storyteller. When Horn died in 1944, his story "Chasing Guinea Jim" was published in two of B.A. Botkin's collections: *Lay My Burden Down* and *Treasury of Southern Folklore*. A narrative that Horn shared with Ruby Pickens Tartt about his marriage to Alice, "A Pair of Blue Stockings," was published in the *Southwestern Review* in the Winter 1944 issue. (Courtesy of the Library of Congress.)

In 1878, Carrie Dykes was born in Belmont, Alabama, where she spent her entire life. Her mother and Creasy, Carrie's aunt, were slaves who belonged to John Morley. Carrie married Samuel Dykes in 1897 and, three years later, gave birth to a daughter, Surfranie. Even though she and her husband were illiterate, she acquired a great deal of folk knowledge regarding midwifery, hoodoo, and superstitions. Carrie estimated that she had delivered between 50 and 60 babies, both black and white. At the time of her interview with Ruby Pickens Tartt, Carrie was caring for "a houseful of children" and a former midwife who was too infirm to live by herself. "Carrie Dykes, Midwife," the life story of Carrie that Ruby Pickens Tartt compiled, appeared in the Texas Folklore Society's publication *From Hell to Breakfast* in 1944. (Courtesy of the Library of Congress.)

Amy Chapman's story, "De Master's Good but Oberseer's Mean," is a personal account of her life as a slave, also known as a slave narrative. The daughter of Bob and Clary Chapman, Amy was born five miles north of Livingston on land owned by Alabama governor Reuben Chapman in 1843. Her children were fathered by the overseer Hewey Leman, a white man. Years later, Leman tried to show responsibility for his children by giving them land on which to live. When members of the Chapman family tried to steal their land, Amy ran to a lawyer's office in Livingston and stopped the sale. (Courtesy of the Library of Congress.)

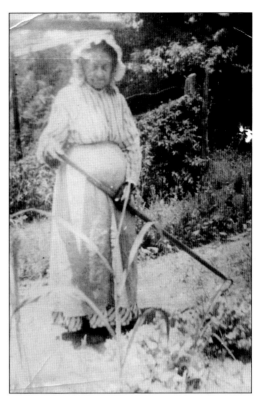

Jake Green was born to Molly and Dan Whitehead in 1852. Their master was Lam Whitehead, who owned a farm near Coatopa, just 10 miles east of Livingston. In his slave narrative, "A Conju' What Didn' Wuk," Jake acknowledged that he did not know his grandparents, but he was close to his four uncles. According to Jake, whenever a neighbor wanted to hire a laborer, his master would rent out one of his four favorite slaves who "could chop as much cotton in a day as a mule could plow." (Courtesy of the Library of Congress.)

Angie Garrett was born in DeKalb, Mississippi. In her slave narrative, "Mules Be Eatin' and Niggers Be Eatin'," Angie discussed her family, including four brothers and three sisters, who lived on Sam Harvard's farm in Gainesville. After Angie was purchased by Captain Mooring, she worked on his boat, the *Cremonia*, and on his plantation. She also vividly recalled being whipped by a cruel overseer named Barnes. Angie spoke of the good times as well, such as corn shucking and marriage celebrations, called "jumping the broom." (Courtesy of the Library of Congress.)

Charity Grigsby thought she was born around 1852, as she told Ruby Pickens Tartt in her slave narrative, "I Knows I's Eighty-five But 'Spect I's More Dan Dat." Her parents were owned by Jim Moore, who ran a small plantation near Ramsey Station. Charity married Nelson Grigsby and gave birth to 11 children. Her master, Jim Moore, was just "tol'ble good to us," but their neighbor Ervin Lavender chased his slaves with dogs. (Courtesy of the Library of Congress.)

George Young was born on a plantation five miles northwest of Livingston on August 10, 1846. In his interview titled "Peter Had No Keys 'Cepin' His'n," George explained to Ruby Pickens Tartt that his parents, Mary Ann Chapman and Sam Young, were the property of Gov. Reuben Chapman. Because the overseers forbade them from going to church, they held services inside an abandoned house and prayed with their heads stuck inside an iron pot so their prayers could not be heard. (Courtesy of the Library of Congress.)

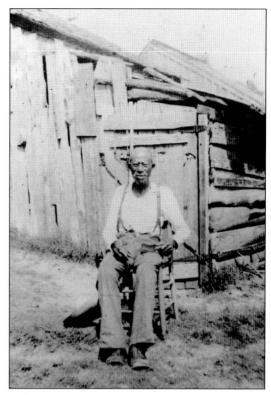

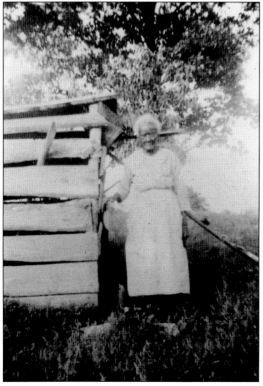

Martha Jackson was born in 1850. In "Heaps of Dem Yaller Girls Got Sont up Norf," Martha shared an anecdote with Ruby Pickens Tartt about a house servant named Tishie, who was so mistreated by her mistress that she ran off. Another slave, however, betrayed Tishie to the "patterollers," or slave patrol. After her capture, Tishie was never seen again. According to Martha, her aunt was immune from punishment because she was a "breeder woman" who gave birth every 12 months. (Courtesy of the Library of Congress.)

Carrie Pollard's narrative, "A Husband Couldn't Be Bought," differs from the other interviews Ruby Pickens Tartt conducted in that Carrie was not really a slave. Cynthia, Carrie's aunt, moved to Gainesville as a child and lived with her guardian, a Mr. Steele. She fell in love with a slave named Tom Dobbs, who lived nearby, but his master would not allow them to marry. Cynthia and Tom had nine children. (Courtesy of the Library of Congress.)

Oliver Bell was born on the DeGraffenreid Plantation, nine miles west of the Livingston-Boyd Road. His parents, Edmund and Luella DeGraffenreid, changed his surname to Bell. In his interview titled "De Bes' Frien' a Nigger Every Had," Oliver expressed that his master, Tresvan De Graffenreid, and his mistress, Rebecca, were good to them, even though he whipped Luella when Oliver was about five years old. (Courtesy of the Library of Congress.)

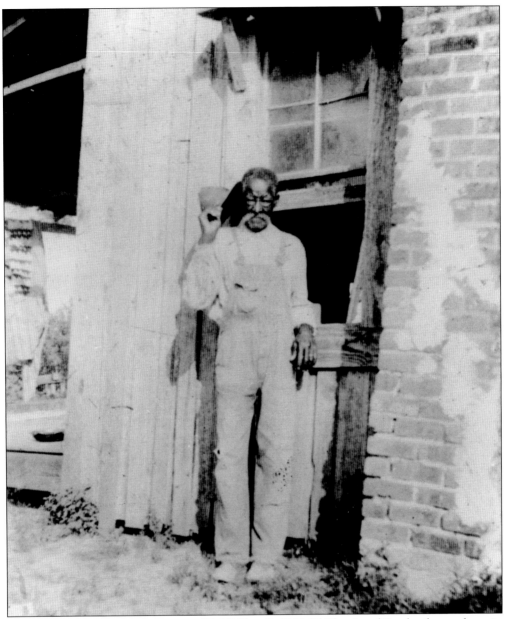

Ank Bishop stated in his interview—"Gab'l Blow Sof'! Gab'l Blow Loud!"—that he was born in 1849. His parents, Amy Larkin and Tom Bishop, were owned by Liza Larkin in Ward, near Coke's Chapel. Even though Ank liked Lady Liza and her son Willie Larkin, he confessed to Ruby Pickens Tartt that one of their slaves, Caesar Townsy, ran away one night and stayed away until after the surrender. He also recalled that all the slave women who were nursing were summoned back to the "Big House" by the ringing of a bell at 9:00 a.m. and at 12:00 p.m. so that they could feed their babies. Ank went on to identify "haints" (ghosts) as the spirits of people who believed in hoodoo or voodoo instead of Jesus Christ. He lamented never learning to read or write and was proud of the fact that his 15-year-old son was literate. Ank concluded with a sweeping statement about life: "Hit's hard, anyway you got to travel, got yo' nose on de ground' rock all de time." (Courtesy of the Library of Congress.)

Henry Garry was born in 1937 on Vandergraaf Plantation, which was owned by John Rogers. He told Ruby Pickens Tartt that his parents stayed on the plantation after the Civil War. As Henry recalled, one night after the surrender, around 100 horsemen wearing white robes rode up to his family's house and ordered his father to give them water. His family later found out that their visitors had been members of the Ku Klux Klan. Henry also spoke of a carpetbagger from up North named Billings, who was lynched. Then he changed the subject to the Confederate cannon that was pulled out of the Tombigbee River and set up in front of the courthouse. He added that the old cannon had been plugged to prevent youngsters from firing it. At the end of his interview, "Mistah Renfroe Hangs on a Chinyberry Tree," Henry recounted a local ghost story about Steve Renfroe, who was lynched from a chinaberry tree in 1886: "I's hyeard iffen you go to dat tree today and kinda tap on it and say, 'Renfroe, Renfroe, what did you do?' Dat tree say right back at you, 'Nothin.' " (Courtesy of the Library of Congress.)

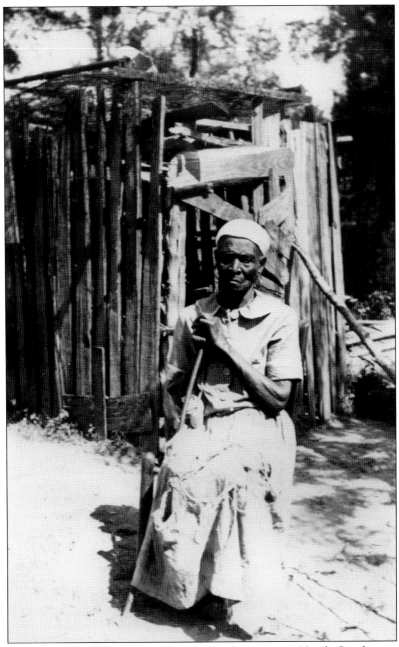

Laura Clark was born in 1851 on Pleasant Powell's plantation in North Carolina, as stated in "Chillun in Ev'y Grabeyard." When she was six or seven years old, she and nine other children were sold to a Mr. Garret, who lived eight miles from Livingston. She was not related to any of the other children, and her mother, Rachel Powell, was left behind. She admitted that she had been "drug about and put through de shackles so bad" that she forgot the names of some of her nine children, whom she raised by herself after her husband died. A boy who belonged to the Miller family killed one of her sons by hitting him on the head with a shovel. He was never arrested for the crime. She ended her interview by revealing that she was blind; she also became lame after a calf stepped on her foot. (Courtesy of the Library of Congress.)

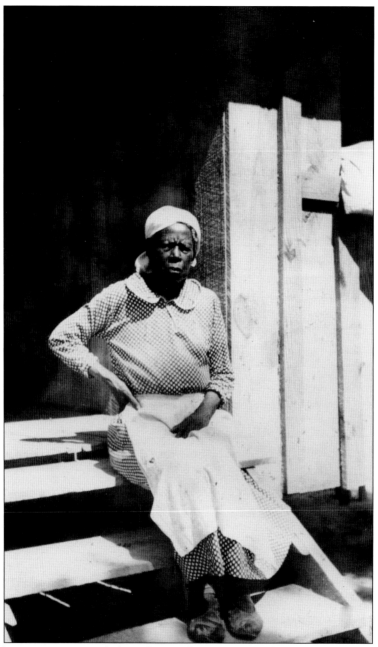

Emma Crockett's interview is titled simply "Ex-Slave Emma Crockett." In her estimation, she was either 79 or 80 years old at the time. Her parents were Alfred Jolly and Casey Hawkins. Their master was Bill Hawkins. Sallie Cotes taught her to read after the surrender, but she regretted not being able to read handwriting. Emma and her husband, Henry Crockett, had five children. After the surrender, she was never bothered by the "patterollers" or by the Ku Klux Klan because she "minded ev'ybody and didn't vex 'em none." Just before the interview, Emma fell down and was unable to remember any folk tales or folk songs. She concluded by saying, "I didn't never fool wid no hoodoo and no animal stories neither. I didn't have no time for no sich foolishness. And I ain't scared of nothin' neither." (Courtesy of the Library of Congress.)

Four

SPECIAL EVENTS, RECREATION, AND WORSHIP

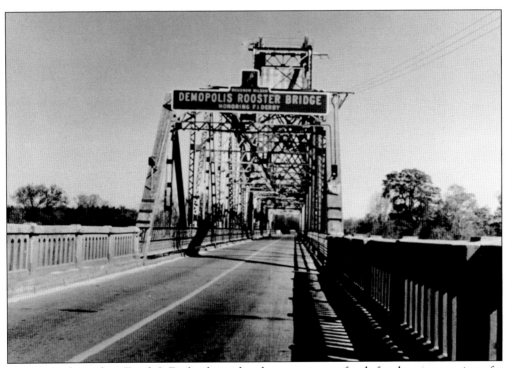

In 1919, York resident Frank I. Derby devised a plan to generate funds for the construction of a bridge across the Tombigbee River, connecting Sumter County and Marengo County, through the sale of roosters. Gov. Thomas Kilby appointed Derby and four other delegates—Thomas Cobb, H.J. Wallace, James C. Webb, and L.K. Simmons—to travel to Washington, DC, to pick up four roosters from Pres. Woodrow Wilson. The roosters had been donated by President Wilson, Premier Clemenceau of France, Premiere Orlando of Italy, and Prime Minister George of Great Britain. Locals paid $10 to enter a rooster in the sale, and over 900 roosters were sold. A special amphitheater was built in Demopolis City Park for the sale. On May 15, 1925, the Rooster Bridge opened on US 80, three miles east of State Road 28. (Courtesy of the Center for the Study of the Black Belt.)

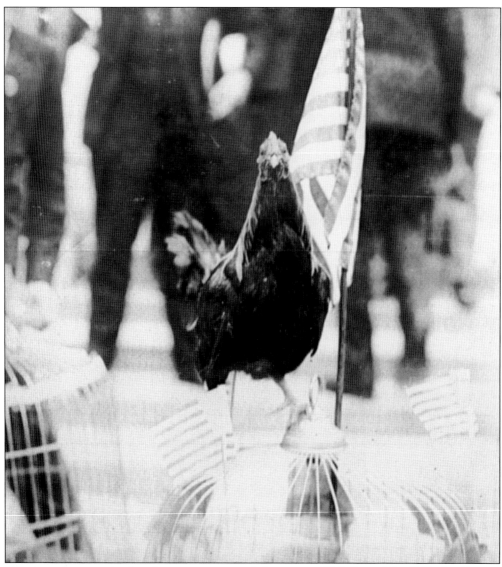

This is a photograph of a champion gamecock known as "Bob Jones." In 1919, the City of Demopolis purchased the rooster, which Frank I. Derby had donated, for $7,500. A Montgomery group pledged $55,000 for President Wilson's rooster but never paid. Some people say that Helen Keller's rooster netted $5,000; others say that her little blue hen went for $15,000. Proceeds from the sales were donated to the "Bridge the Bigbee with Cocks" campaign. (Courtesy of the Center for the Study of the Black Belt.)

In this photograph dated August 1, 1960, standing at the base of the Rooster Bridge are, from left to right, Ralph Webb Gardner, Frank I. Derby, Minnie Wade Derby, and Carrie Gardner. The old bridge was demolished in 1980 to make room for a more modern bridge across the Tombigbee River. (Courtesy of the Center for the Study of the Black Belt.)

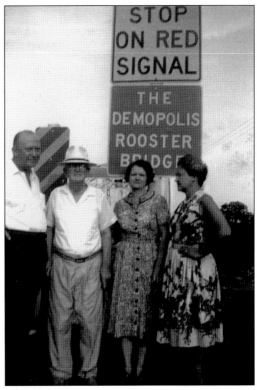

On May 12, 1960, Sumter County residents Carrie Gardner (left) and Mary Thompson Evans (center) met First Lady Edith Wilson (right) at the National Cathedral in Washington, DC. Edith Wilson had an abiding interest in Sumter County following her husband's involvement in the construction of the Rooster Bridge in 1919. (Courtesy of the Center for the Study of the Black Belt.)

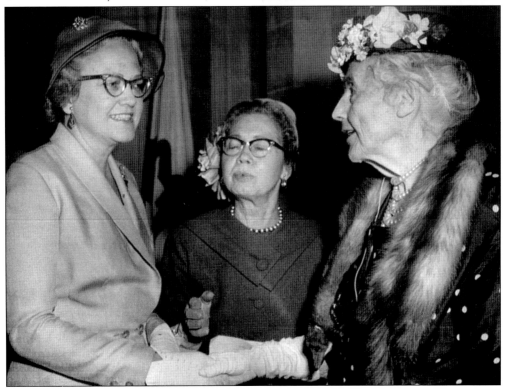

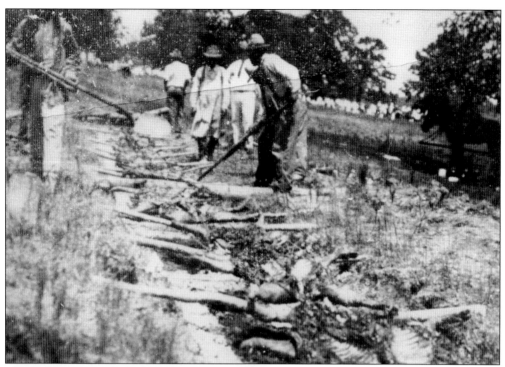

Barbecues have always been a favorite pastime in Sumter County. Before the Civil War, Southerners developed a fondness for slowly roasted meat slathered in a flavorful sauce. As the photograph demonstrates, the meat was placed over the pit on greenwood sticks. Typically, two experienced pit masters and a young apprentice prepared the meat. (Courtesy of Joe Taylor.)

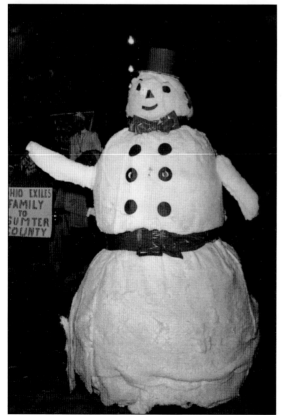

The DUD parade is held in Livingston every New Year's Eve. The official meaning of DUD is unknown, although some believe it stands for "Damned Ugly Devils." During the parade, which has been in existence since the mid-19th century, bankers, lawyers, college professors, and ordinary men, all dressed in outlandish costumes, march through the town square. In 1956, this Frosty the Snowman took first place. (Courtesy of the Julia Tutwiler Library.)

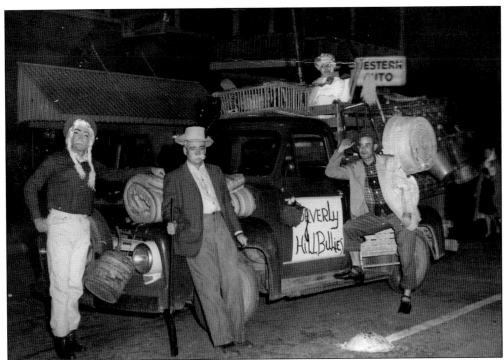

Through the years, marchers have derived their inspiration from everywhere, from television and movies to the *Weekly World News*. In 1965, this group paid homage to *The Beverly Hillbillies*, a sitcom starring Buddy Ebsen and Irene Ryan that ran on CBS from 1962 to 1971. From left to right are (above) Robert Ennis, Richard Ennis, James Scruggs, and Lewis McLeon; (below) Robert Ennis, Lewis McLeon, James Scruggs, and Richard Ennis. (Both, courtesy of the Julia Tutwiler Library.)

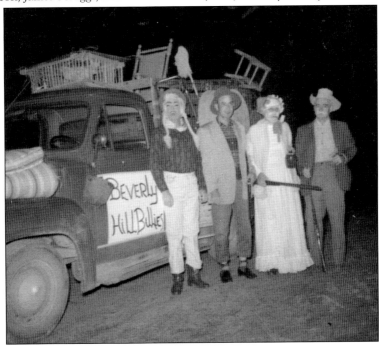

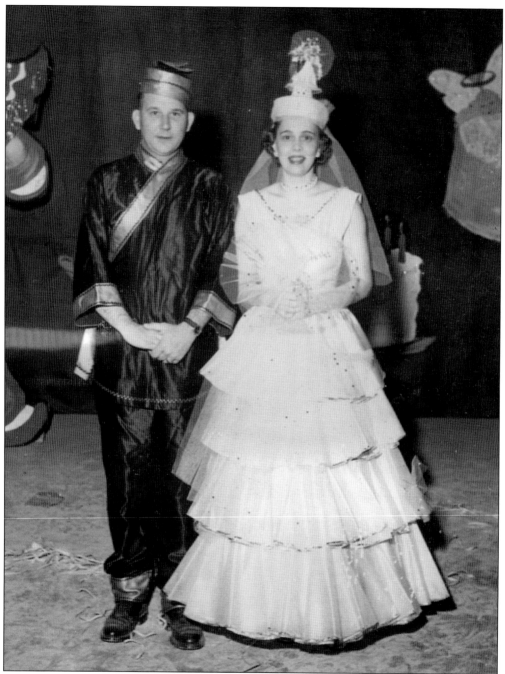

On September 15, 1951, a group of women from Livingston organized the Masquers. Their mission was to keep the DUD traditions alive and hold a dance on New Year's Eve. The first Masquers Ball was held in the high school gym on December 31, 1951. Husbands of the Masquers members were required to march in the DUD parade. On December 31, 1956, the theme of the dance was "Cakes and Cookies." The president, Mrs. Frank Bullock, dressed as a tiered wedding cake, while her husband seems to have forgone the theme in favor of his Asian costume, perhaps a carryover from the parade. (Courtesy of the Julia Tutwiler Library.)

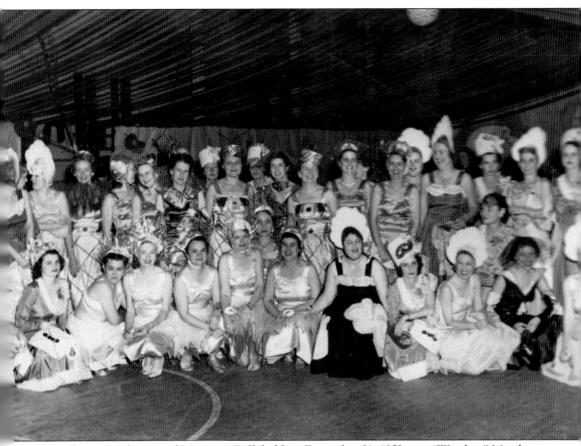

The theme for the second Masquers Ball, held on December 31, 1952, was "Weather." Members present include, from left to right, (first row) "Toogie" Seale, Jean Ennis, Lizzie Scruggs, Trice Smith, Mrs. Jimmy Atkinson, Epsie Story, Mrs. Louis Allen, Gladys Tartt, Clara Grant, Sarah Richardson, Mary Elizabeth Davis, Mattie McDade, Gregor Smith, and Evelyn Bruner; (second row) Ludie Williams, Dorothy Nelson, Dorothy Tart, unidentified, Nell Ennis, Elise Pruitt, Sarah Hoover, Martha Flicker, unidentified, Louise Tartt, Mrs. William Glass, Wyonia White, Martha McDaniel, Sis Braiton, Lucille Lundy, Lillis Allison, Oralee Tartt, and Lutie Killebrew. (Courtesy of the Julia Tutwiler Library.)

Gainesville has been a popular setting for Civil War reenactments since the first one was held in Cook's Grove in 1965. Gainesville is an ideal site for Civil War reenactments because Gen. Nathan Bedford Forrest surrendered there on May 9, 1865. At left, John A. Rogers III (right) is standing in full uniform. Below are three female reenactors: Nelle Goggans (left), "Banbana" Sparkman (right), and Stephanie. Other reenactors portrayed clergy, medical officers, and sutlers, the merchants who followed armies around to peddle their wares and clothing. Since then, thousands of people have traveled to Gainesville during the second weekend in March to witness the firing of the cannon and the dramatic clashes between Union and Confederate cavalry. Memorial services are held at the Forrest Monument and the Old Confederate Cemetery, where over 120 Confederate soldiers from the Battle of Shiloh are buried. (Both, courtesy of the Sumter County Historical Society.)

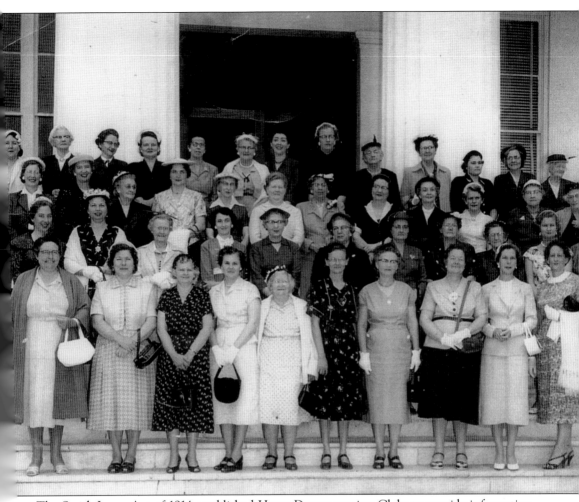

The Smith-Lever Act of 1914 established Home Demonstration Clubs to provide information on agriculture and home economics to those who did not attend college. This program was coordinated between the US Department of Agriculture and the state land-grant colleges. Female agents visited women living in rural areas and presented programs on canning, cooking, raising poultry, gardening, sewing, household cleaning, child rearing, and preserving meat with a pressure cooker. The clubs also provided social opportunities for women living in isolated areas. Women learned from the scientific methods demonstrated by the presenters, as well as from each other. Because the Home Demonstration Clubs seemed to promote conservative domestic values, they began to fall out of favor in the 1960s and 1970s. In this photograph, the Home Demonstration Club from Sumterville is gathered on the steps of the Montgomery capitol building in the 1950s. (Courtesy of the Sumterville Community Center.)

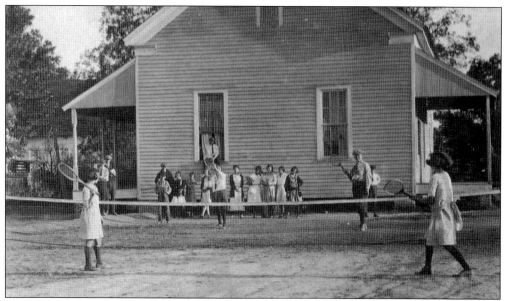

Modern badminton, which emerged in 19th-century Great Britain and the United States, evolved from battledore and shuttlecock, which were played in ancient Greece, China, India, and Japan. Like croquet, badminton was considered an outdoor sport that refined ladies and gentlemen could play without overexerting themselves. Remaining prim and proper at all times was particularly important for ladies of the Victorian era. These girls from Cuba High School are playing this genteel sport in the yard in the 1920s. (Courtesy of the Julia Tutwiler Library.)

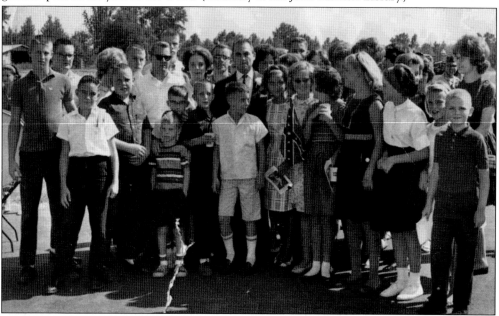

Alabama governor George Wallace (center) attended the dedication of the York Airport in the mid-1960s. Wallace served four terms as governor, two of which were consecutive: 1963–1967, 1971–1979, and 1983–1987. His total time spent in office was 5,848 days, the third-longest tenure in post-Constitutional history. He also ran for president four times. Wallace was paralyzed in an assassination attempt in 1972, and he died in 1998. (Courtesy of the Cuba Museum.)

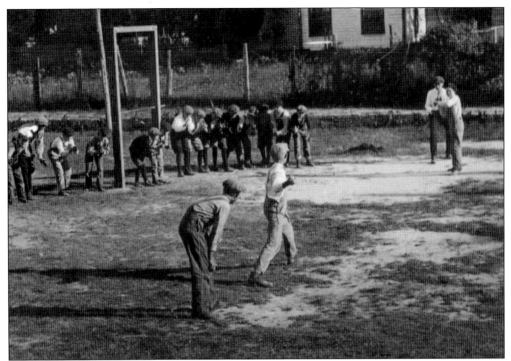

Sumter County High School was built in Cuba in 1913; it closed in 1949. The high school was located on the corner of Highway 11 and Country Club Road (Millville Road). Students played baseball and football on the field behind the school, facing south toward Highway 11. This photograph was taken in the 1920s. (Courtesy of the Cuba Museum.)

This photograph of the Alamucha Cokes Chapel baseball team was taken in the early 1900s. From left to right are (first row) Walter Harwell, Johnny Dearman, Rob Harwell, and Ezell Pratt; (second row) Jim Tew, Pratt Ezell, Joseph "Sonny" Grace, Ben Tew, and coach Tom Cahoon. (Courtesy of the Ward, Alabama Museum.)

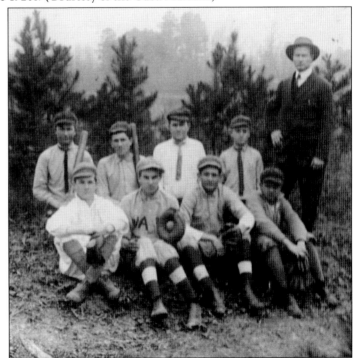

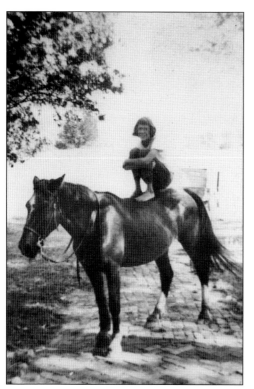

In this 1949 photograph, Margaret Ramsay is crouching on the back of her mare Old Babe at Farview Plantation in Sumterville. Margaret said, "I always called her a Shetland Pony. Of course, she wasn't." Even though Margaret viewed Old Babe as a pet, most horses on farms at this time were work animals. (Courtesy of Margaret Ramsay.)

Not all horses living in Sumter County were put to work pulling plows in the fields. In this 1947 photograph, Cherry Austin is sitting astride her show horse. Her mother, Stella, was a former girlfriend of Frank Derby Jr. This particular horse was probably worth several thousand dollars. (Courtesy of the Center for the Study of the Black Belt.)

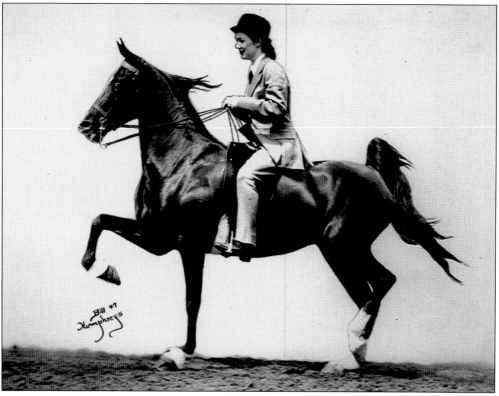

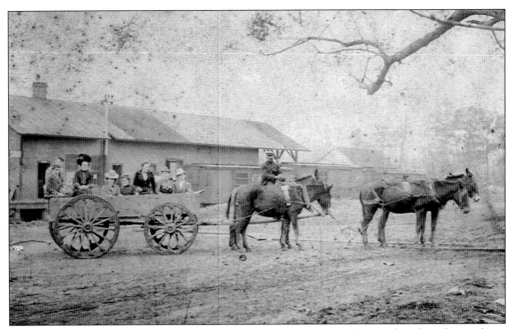

On many farms, mules were preferred to horses because they eat less, endure heat better, have fewer hoof problems, and require less overall maintenance. Members of the Allison and Derby families are pictured riding in a mule-drawn wagon driven by Ock Wallace in December 1900. (Courtesy of the Center for the Study of the Black Belt.)

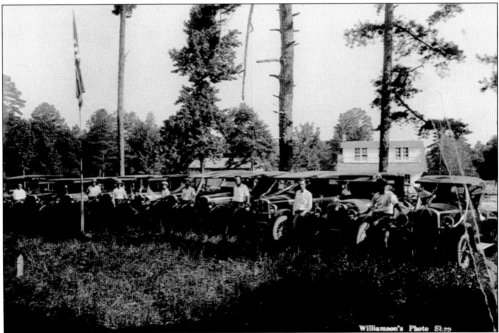

From 1900 to 1935, the Derby family frequently used Buckhorn Camp, a deer camp in Bellamy. Many of the men who hunted at Buckhorn Camp were friends and business associates of the Derbys. Even state and politicians enjoyed roughing it at Buckhorn Camp. (Courtesy of the Center for the Study of the Black Belt.)

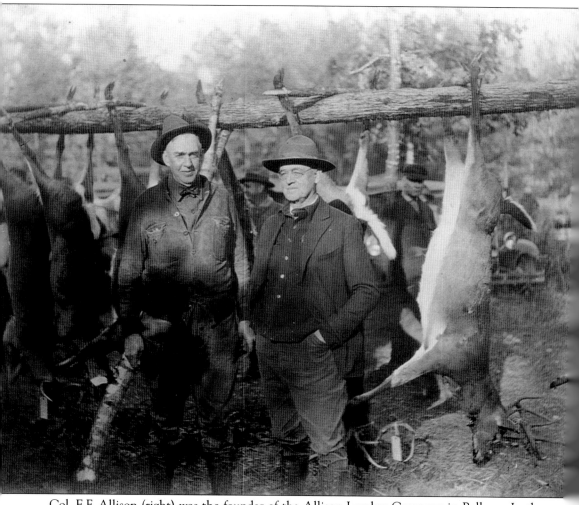

Col. E.F. Allison (right) was the founder of the Allison Lumber Company in Bellamy. In the 1920s, the Derby family was close to the Allison family. In this photograph, Colonel Allison is posing with an unidentified comrade in front of a neat rack of deer after a highly productive day of hunting at Buckhorn Camp. (Courtesy of the Center for the Study of the Black Belt.)

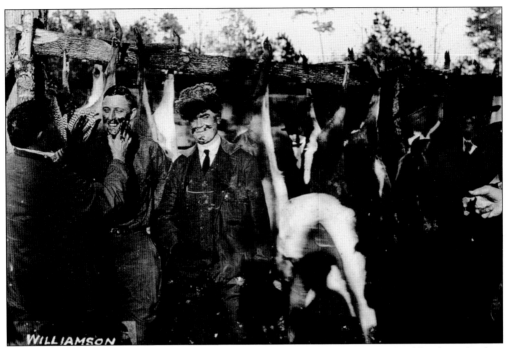

One of the most revered hunting traditions at Buckhorn Camp was smearing blood on the face of a hunter who had taken his first deer. This ritual dates back to 16th-century England, where fox hunters smeared blood on the face of those who had killed their first fox. (Courtesy of the Center for the Study of the Black Belt.)

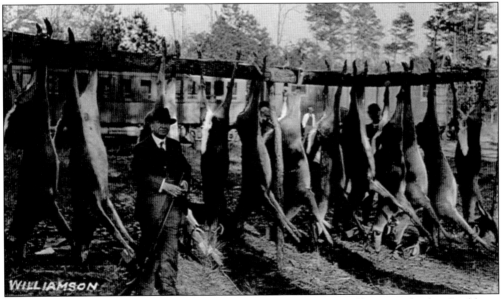

Even Alabama governor Thomas Kilby was attracted by the prospect of bagging a buck at Buckhorn Camp in the 1920s. Kilby served as lieutenant governor from 1915 to 1919 and as governor from 1919 to 1923. The Child Welfare Department was created during his administration in 1919. When his image graced the Alabama centennial half dollar in 1921, he became the first person to appear on a US coin while still alive. (Courtesy of the Center for the Study of the Black Belt.)

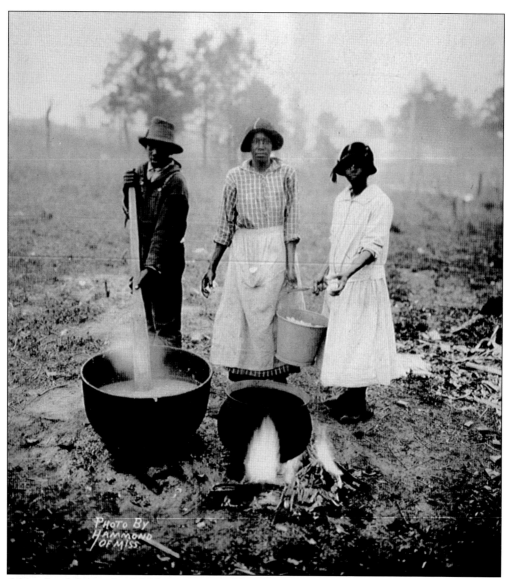

After a hard day in the field, hunters at Buckhorn Camp enjoyed a hearty meal. A favorite dish was Brunswick stew, a thick vegetable soup prepared by this unidentified African American family who worked for the Derbys. Brunswick stew is a tomato-based dish of lima beans, okra, corn, and other vegetables. In rural areas, squirrel, opossum, or rabbit meat was added. Meat substitutes include chicken, beef, or pork. The origin of Brunswick stew is unknown, but it remains popular in the South. (Courtesy of the Center for the Study of the Black Belt.)

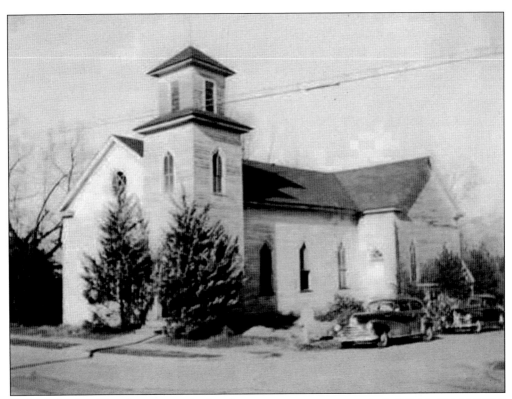

York Methodist Church was organized and constructed on land donated by Warner Lewis and R.A. Clay. Charter members and organizers of the York Methodist Church included the Ward family, Hall family, Poole family, Thompson family, and Garrison family, along with Agnes Lynn and her son Morgan Lynn. (Courtesy of the Sumter County Historical Society.)

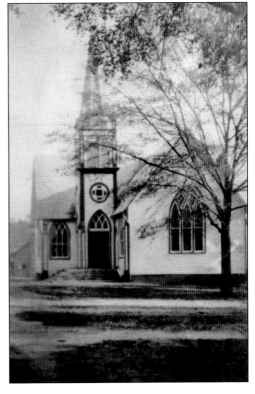

Before master carpenters Phillip Jones and John W. Adams built the Livingston Methodist Church in 1838, the congregation met in the old log courthouse. Hand-hewn timbers and whip-sawed planks were used in the construction of the church. The old church sustained heavy damage during the Civil War and was finally torn down in 1891. The following year, a new church was erected on the corner of Washington and Madison Streets. Bishop Galloway presided over the dedication. (Courtesy of Joe Taylor.)

St. James Protestant Episcopal Church was organized in Livingston in 1836. The members met at a building that stood at the intersection of Monroe and Jefferson Streets. The lot on which the present church stands was donated by Willis Crenshaw, a Presbyterian. Legend has it that the church's first bell was a steamboat bell. Bishop Leonidas Polk is said to have presided over the consecration of the church. Polk, a lieutenant general in the Civil War, was killed during the Atlanta campaign in 1864 while serving under Gen. Joseph E. Johnston. (Courtesy Joe Taylor.)

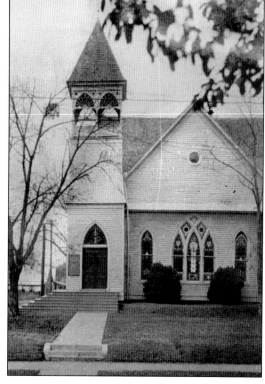

The Livingston Presbyterian Church was organized on August 11, 1833. In 1834, M.C. Houston donated a lot for the new church at the corner of Washington and North Streets. Houston and a prominent member of the church, Squire James Hair, procured the lumber for the church. Construction was completed in 1838, and the old church was renovated in 1900. The old part of the church became the Sunday School room. (Courtesy of Joe Taylor.)

The Gainesville Presbyterian Church was organized in 1835. The congregation met in the lecture hall a block away until construction of the church was completed in 1837. Approximately 500 silver dollars were melted down to make the bell. John Leybourne, the first preacher, was succeeded by John L. Kirkpatrick, Charles A. Stillman, and Albert A. Moore. Stillman went on to found the Stillman Institute for black education, now known as Stillman College in Tuscaloosa. As a slave, Maria Fearing sat in the balcony; later, she became a missionary in Africa. (Courtesy of the Sumter County Historical Society.)

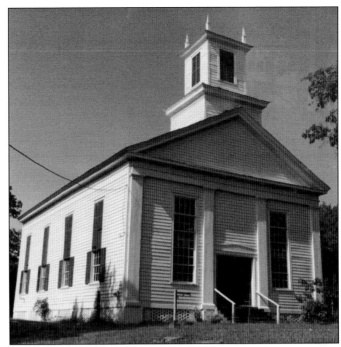

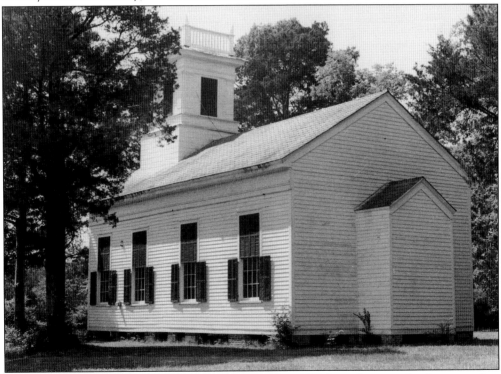

Edward Kring built the Gainesville Methodist Church in 1879. Its architectural style mimics that of the Gainesville Presbyterian Church, although on a smaller scale. Arched niches protrude from both the front and rear facades. Some believe that this church replaced an earlier Methodist church that had been destroyed. (Courtesy of the Sumter County Historical Society.)

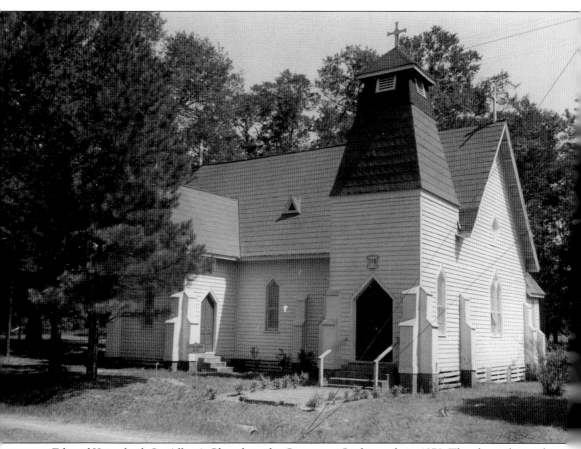

Edward Kring built St. Alban's Church in the Carpenter Gothic style in 1879. The altar is located on the east end, and the entrance is situated at the base of the bell tower on the northwest corner. The old church's stained-glass windows have been carefully preserved, the most notable of which are the trinity above the altar and the diamond-shaped window on the west end, representing the eye of God. (Courtesy of the Sumter County Historical Society.)

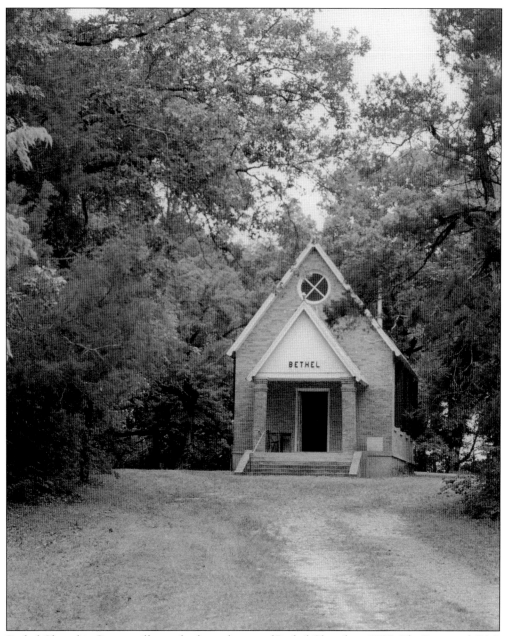

Bethel Chapel in Sumterville was built on the site of Bethel Church in 1908. The Reverend C.M. Hutton of Texas presided over the dedication of the chapel, which was designed as a memorial to Confederate soldiers in the area. The soldiers' records are inscribed on marble plaques inside the chapel. William McDow erected the iron fence around the graveyard behind the church. For many years, hundreds of people observed Decoration Day inside the old cemetery, which contains the graves of several Bethel Church founders. (Courtesy of Margaret Ramsay.)

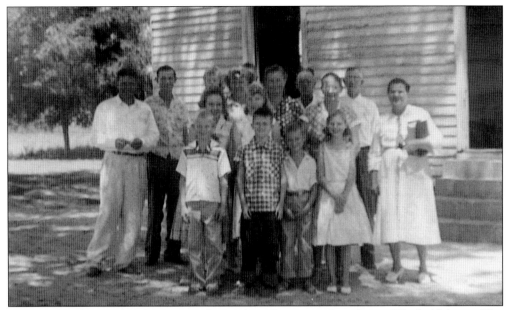

The Ward Holiness Church was one of several small centers of worship in Ward, Alabama. The church burned in 1979. This photograph of the congregation was taken in the late 1950s or the early 1960s. From left to right are (first row) Ceed Radcliffe, Danny Curtis, Buddy Radcliffe, and Patsy Radcliffe; (second row) Gloria Jean Moody and Mae Radcliffe; (third row) Clyde Taylor, Johnny Radcliffe, Agnes Moody, Geneva Moody, Gene Moody (obstructed from view), Maureen Radcliffe, Mr. and Mrs. Wright, Will Radcliffe, and Mary Alma Radcliffe. (Courtesy of the Ward, Alabama Museum.)

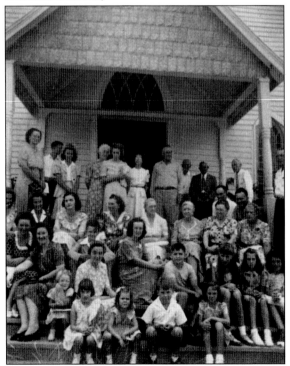

The Bethel Presbyterian Church was established in Sumterville in 1835. The present church stands on land purchased from the Hale family. The Reverend J.D. McLean officiated the dedication on August 4, 1897. This Sunday school photograph was taken in 1946. In the center of the first row are Margaret and Lawrence Ramsay, with their brother Andrew sitting behind them. (Courtesy of Margaret Ramsay.)

Five

MAKING A LIVING

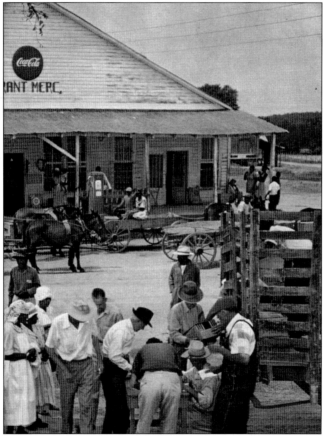

In 1924, T.L.S. Grant built the Grant Store in Ward. The general store offered food staples, clothing, cooking utensils, feed and seed, farm implements, tools, and medicine. The post office was housed in the front of the store, and a doctor's office was located in the back. Medicine was dispensed from a small room between the main store and the post office. In this 1955 photograph, which originally appeared in the September 10, 1955, edition of the *Saturday Evening Post*, welfare workers are distributing cheese, dry milk, shortening, and rice to farmers whose crops had been ruined in a drought. The food came from federal surpluses. The old Grant Store is currently owned by David and Betty Grant. As a boy, David worked in the store for William H. Grant, the son of T.L.S. Grant. The store turned museum displays antiques the Grants have collected, as well as items that were sold in the store. (Courtesy of the Ward, Alabama Museum.)

Kate Bayliss's store was the place to go for baloney-and-cheese sandwiches and canned goods in Sumterville. It also had a refrigerator where children could buy Popsicles. A dance was held at the store for its grand opening in the 1940s. In this 1965 photograph, Kate (left) and her sister are sitting on the front porch of the store. Following Kate's death, the store closed in the 1980s, but the building is still standing. (Courtesy of Sumterville Community Center.)

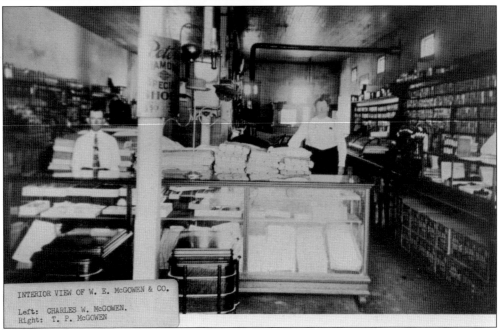

INTERIOR VIEW OF W. E. McGOWEN & CO.

Left: CHARLES W. McGOWEN.
Right: T. P. McGOWEN

This building, constructed in Cuba in 1880, housed a store owned by C.W. Poole, followed by another store, known as W.E. McGowen & Co. Pictured here are Charles W. McGowen (left) and T.P. McGowen, a charter member of the Presbyterian Church in 1906. He also was a representative in the state legislature. (Courtesy of the Cuba Museum.)

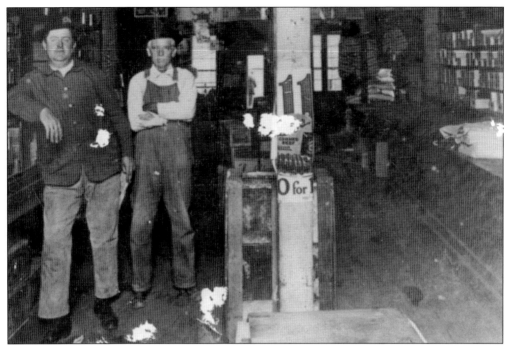

Vaughn's Grocery was located in the oldest store building in Cuba. The heart pine timber used in its construction was taken from an old demolished hotel in Kewanee, Mississippi. Ward Vaughn is standing at left; the man at right is unidentified. (Courtesy of the Cuba Museum.)

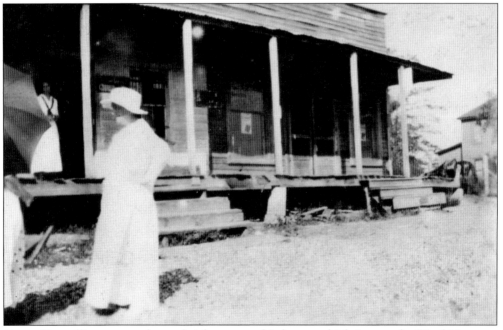

Stuart Harwell's store was located right next to his home, which is now the Ward Museum. Because the store was painted red, it was known as "the Red Store." At least a portion of the store's success in the early 1900s can be attributed to its Coke soda fountain. (Courtesy of the Ward, Alabama Museum.)

On April 19, 1897, Herman Ward Stegall was born to James Solomon Stegall and Matilda Ennis Daniel Stegall in Pontotoc, Mississippi. The Stegalls moved to Emelle, Alabama, in 1902. After serving in World War I, Herman became a rural mail carrier in the Emelle area. Those who lived along his route stated that he occasionally put unusual items in their mailboxes to scare them, sometimes snakes. (Courtesy of Lolita Smith.)

Herman Ward Stegall married Louise Estelle Wood of Pontotoc County, Mississippi, in 1918. In this 1920 photograph, she is sitting astride the motorcycle that Herman used on his mail route. Later, the couple moved to Pontotoc, Mississippi, where Herman worked as an insurance agent. Herman died on June 4, 1927, under what the *Tupelo Journal* referred to as "peculiar circumstances." Six months later, his wife married former sheriff Palmer Blaylock. Louise Wood Stegall-Blaylock was indicted for poisoning her late husband but was released on September 18, 1928. (Courtesy of Lolita Smith.)

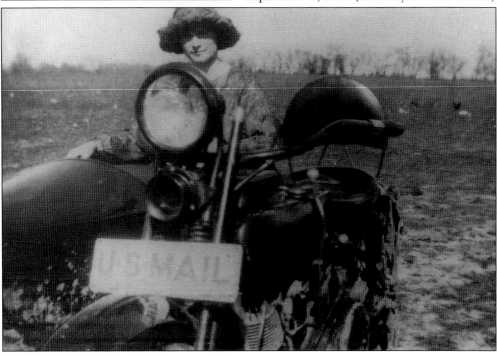

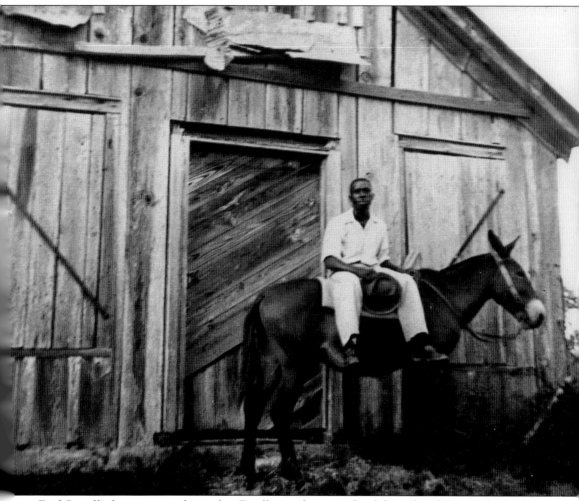

Fred Stegall's first store was located in Emelle, on the east side of the railroad. Pictured in 1935, Buddy Soc Hutchins, Fred's first customer, is seated on a mule in front of the frame store. In the 1930s, most citizens of Emelle did their shopping locally because few people owned automobiles. African American families came to town in the mornings to shop, socialize, and eat fried fish prepared by Ella Duck or Beck Eason. (Courtesy of Lolita Smith.)

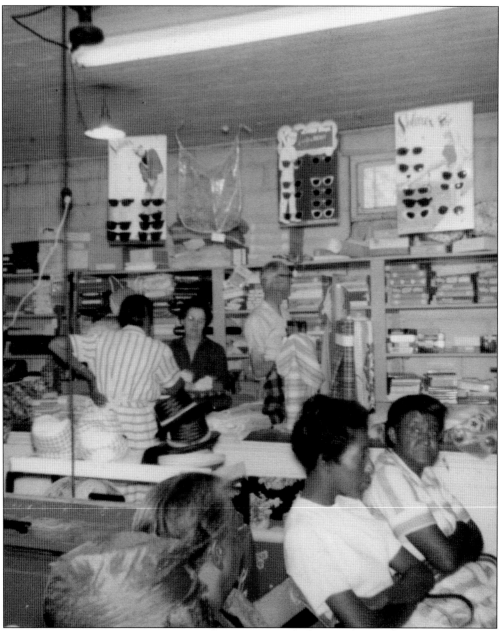

Fred Stegall's second store was constructed with cement blocks. Stella and Fred Stegall are seen here behind the counter in 1960. The customer they are waiting on is Anna Bertha Foy. Tenant farmers paid their tabs in the fall when their cotton was ginned. Fred told his nephew Joe Stegall that, in all the years he operated stores in Emelle, only a few of his customers had outstanding bills. (Courtesy of Lolita Smith.)

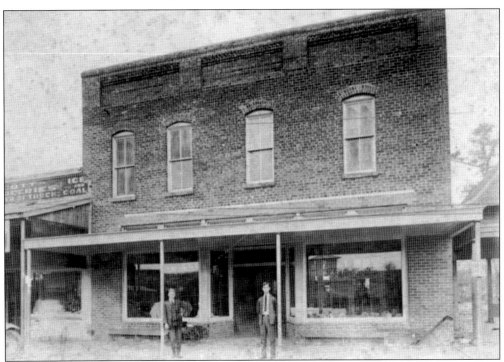

The first business housed in what is now the Hightower Center in Cuba was F.M. Cobb & Son. Pictured here in 1922 are Bascomb Hitt (left) and Henry Grade Cobb, father of J. Everett Cobb. Years later, C.B. Hightower Jr. took over the store. (Courtesy of the Cuba Museum.)

Before the invention of Eli Whitney's cotton gin, hundreds of man-hours were required to separate the seeds from cotton bolls. In the 19th century, cotton production had become so profitable that planters bought more land and more slaves. Thanks to the Black Belt's rich black soil, Alabama became one of the most productive agricultural regions in America. In 1911, more than 1,000 bales of cotton were ginned at the Cuba Cotton Gin. (Courtesy of the Cuba Museum.)

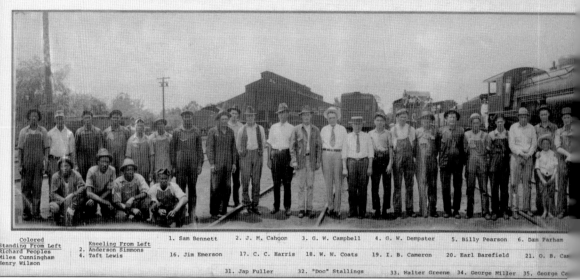

1. Sam Bennett 2. J. M. Cahoon 3. G. W. Campbell 4. G. W. Dempster 5. Billy Pearson 6. Dan Parham

16. Jim Emerson 17. C. C. Harris 18. W. W. Coats 19. I. B. Cameron 20. Earl Barefield 21. O. B. Ca

31. Jap Fuller 32. "Doc" Stallings 33. Walter Greene 34. George Miller 35. George Co

The Alabama, Tennessee & Northern Railroad (AT&N) was instrumental in the development of rural Alabama. It began as the Carrollton Short Line, which was chartered by Alabama in July 1897. The local economies were boosted tremendously by the dummy lines connected to the Carrollton Short Line. These dummy lines tapped the area's vast timber holdings that had been almost unreachable before the advent of the railroad. On September 29, 1906, the name of the line was changed to the Alabama, Tennessee & Northern Railroad. The 75-mile rail line was

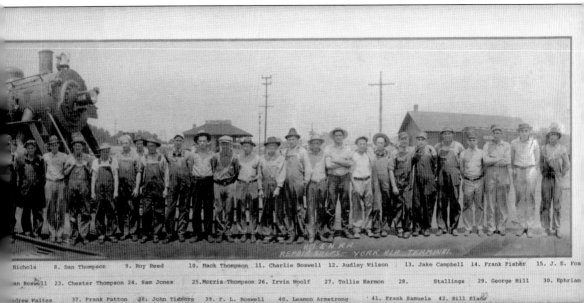

Nichols 8. Dan Thompson 9. Roy Reed 10. Mack Thompson 11. Charlie Boswell 12. Audley Wilson 13. Jake Campbell 14. Frank Fisher 15. J. E. Fox

an Boswell 23. Chester Thompson 24. Sam Jones 25.Morris Thompson 26. Irvin Woolf 27. Tollie Harmon 28. Stallings 29. George Hill 30. Ephriam

drew Waites 37. Frank Patton 38. John Tidmore 39. F. L. Boswell 40. Leamon Armstrong 41. Frank Samuels 42. Bill Slade

completed from Reform to York in 1910. The AT&N was reorganized in 1918 after undergoing foreclosure. Then, in 1928, the AT&N was extended from Calvert to Mobile. In 1946, the AT&N became one of the first railroads its size to switch over to diesel engines. It officially merged with the St. Louis–San Francisco Railway (the Frisco) in 1971. On November 21, 1980, the Frisco became part of the Burlington Northern Railroad. The above photograph was taken around 1930 in Bellamy, Alabama. (Courtesy of the Center for the Study of the Black Belt.)

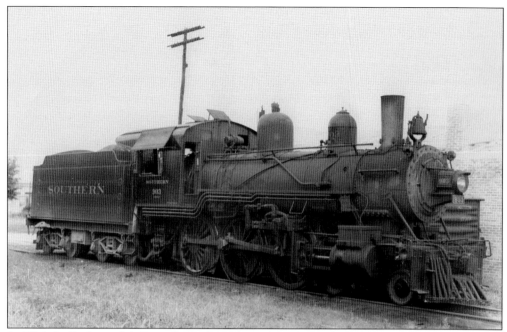

In 1894, the Richmond & Danville Railroad (R&D) merged with the East Tennessee, Virginia & Georgia Railroad (ETV&G) to form the Southern Railway (SOU). Other railways soon fell on the SOU's control as well, such as the Alabama Great Southern (AGS) and Alabama & Vicksburg (A&V) Railroads. By 1916, the SOU covered 8,000 miles and 13 states. This Southern 903 engine, pictured in 1947, ran between York and McDowell. (Courtesy of the Julia Tutwiler Library.)

Most small-town depots had only one agent. In most towns, the agent opened the depot at 7:00 a.m. or 8:00 a.m. Depot agents sold tickets, made out freight reports, copied telegrams in Morse code, and processed express package shipments for Wells Fargo Co. Express. In the early 1900s, the Ward depot agent was Alliene Harwell, the daughter of Stuart and Lula Harwell. (Courtesy of the Ward, Alabama Museum.)

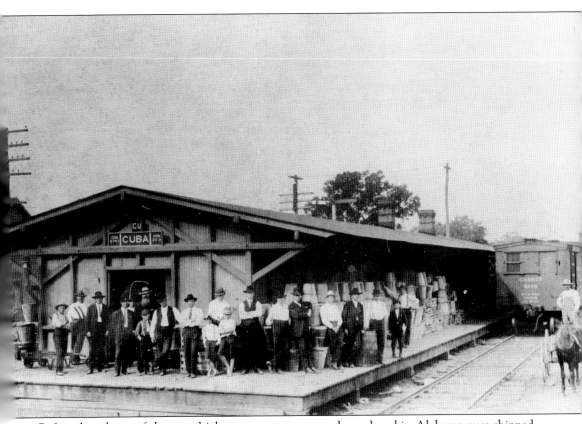

Before the advent of the state highway system, most goods produced in Alabama were shipped by train to markets in the East. In the early 1990s, trains departing from the Cuba railroad depot transported cotton grown in Cuba and processed in nearby cotton gins. The old depot was torn down in the 1960s. (Courtesy of the Cuba Museum.)

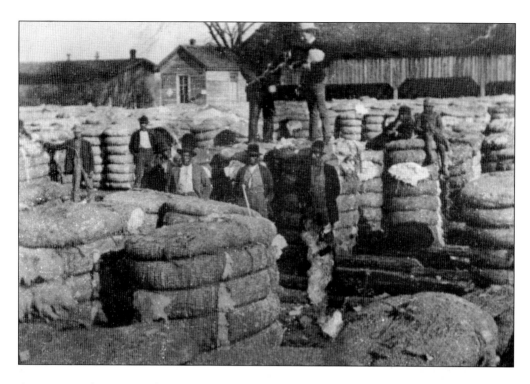

A cotton warehouse owned by John L. Horn, J.P. Spratt, C.C. Seale, Alex G. Horn, and Clarence Larkin was built near the Livingston railroad depot in 1886. Prior to this time, cotton was piled in the streets around the courthouse. The warehouse blew down in 1916, but a new one was not built until 1934. Above, Andy Moore (left) and W. Champ Pickens are standing on the bale of cotton at center. Below, a load of cotton is being hauled to J.C. Arrington's cotton gin. (Both, courtesy of Joe Taylor.)

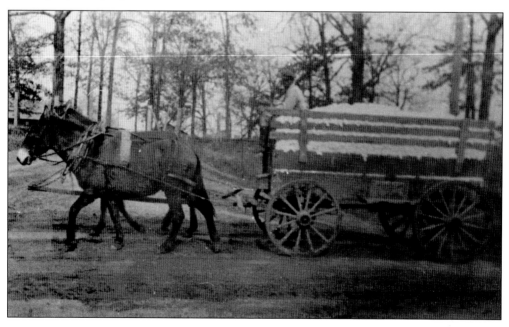

Williamson's Photo Shop

In the 1920s, land sales were big events, probably because most people in Sumter County made their living on the land in one way or another. Frank I. Derby presided over this particular sale for the Pinehurst property. The auctioneer was P.M. Gross. (Courtesy of the Center for the Study of the Black Belt.)

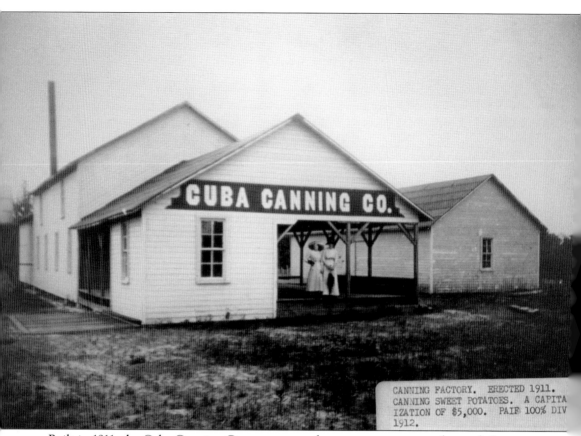

CANNING FACTORY. ERECTED 1911.
CANNING SWEET POTATOES. A CAPITA
IZATION OF $5,000. PAIE 100% DIV
1912.

Built in 1911, the Cuba Canning Company canned sweet potatoes grown by truck farmers in
Sumter County. In 1912, the year this photograph was taken, the Cuba Canning Company paid 100
percent dividends. The company was closed by the 1940s. (Courtesy of the Cuba Museum.)

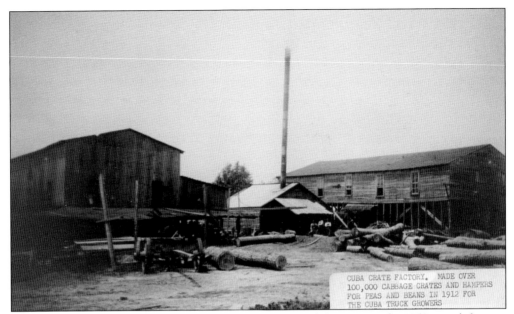

By 1900, Cuba had become known as the truck center of Alabama. Into the 1950s, truck farmers in Alabama raised English peas, beans, cabbages, and Irish potatoes, on 20, 30, or 40 acres of land. After harvest, the farmers drove through the small towns yelling, "String beans! String beans!" The crates used by truck farmers in Sumter County were made in the Cuba Crate Factory, pictured here. (Courtesy of the Cuba Museum.)

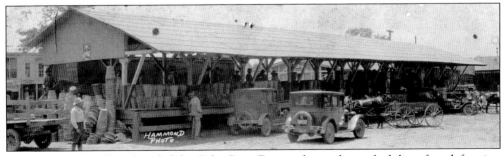

In 1900, Frank McElroy founded the Cuba Crate Factory due to the profitability of truck farming in the area. In 1912, the Cuba Crate Factory made over 100,000 cabbage crates and hampers for beans and peas. In this photograph, crates are being loaded into cars, trucks, and mule-drawn wagons for use on truck farms. (Courtesy of the Cuba Museum.)

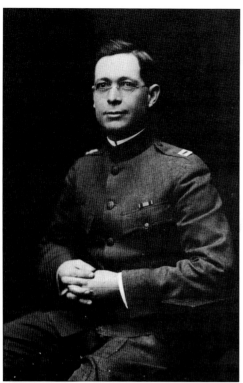

Eugene Hale was born about 10 miles south of York on November 17, 1874. Even though his father was a doctor, Eugene initially was interested in journalism, but he eventually decided to make medicine his career. After returning from service in World War I, he became a country doctor who, according to the October 19, 1958, edition of the *Tuscaloosa News*, "practiced medicine from his saddlebag," making house calls all over Sumter County and beyond. During the last decade of his life, Hale worked diligently to establish a tuberculosis hospital in West Alabama. He died in 1955, three years before Hale Memorial Hospital opened in Tuscaloosa. (Courtesy of the Center for the Study of the Black Belt.)

Dr. Amos L. Vaughn was born on February 12, 1864. He was one of the last of the old "nursing" doctors. He graduated at the University of Louisville School of Medicine in 1884, then began his practice with Dr. Henry B. Ward in Ward, Alabama, that same year. Vaughn married Allie Ward, a relative of Dr. Ward. He devoted most of his later life to the operation of his drugstore. People who knew Vaughn described him as a rugged and outstanding country doctor. He died on August 31, 1923. Included in the photograph are, from left to right, Dr. A.L. Vaughn, Jake Vaughn, Holland Treadway, and Louie Vaughn. (Courtesy of the Cuba Museum.)

In 1878, Dr. Henry Bascomb Ward graduated from the Alabama Medical College at Mobile. He practiced medicine in Cuba from 1880 to 1905. Ward was a member of the First Alabama Board of Medical Examiners, the counselor of the state medical association, the president of Sumter County Medical, a steward of Cuba Methodist Church, and the first mayor of Cuba. Ward also was a farmer, banker, and merchant. He opened his general store in 1881. Dr. Henry B. Ward died on March 5, 1930; he is buried in Clay Memorial Cemetery. (Courtesy of the Cuba Museum.)

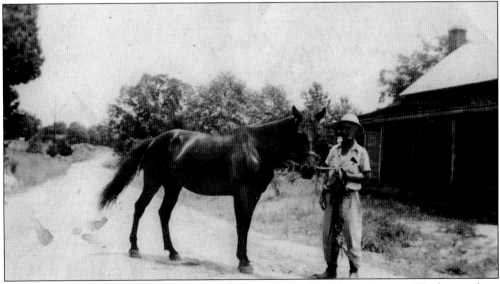

In addition to serving as a physician in Cuba for 25 years, Dr. Henry Bascom Ward ran a farm in the town of Ward. In the 1940s, Timothy Hay became the first overseer of the H.B. Ward estate to live in Ward. Although the cotton house has been torn down, the overseer's house and the barn are still standing. In May 1988, Edward and Corrie Rew purchased the property from Richard Gangne. (Courtesy of the Ward, Alabama Museum.)

John William Ormond worked as overseer of the Farview Plantation in the early 20th century, when Annie Stewart Morrow Fulton lived there. He managed the planting of crops and cared for the cattle. Later, he became the overseer of a farm in Geiger. (Courtesy of Margaret Ramsay.)

The Gordon mill and dam were built on the south side of Ward in the late 1800s. The flow of water was controlled by a sluice gate. A millstone, similar to the ones used in the Gordon mill, is on display at the Grant Store in Ward. The mill house fell around 1925. (Courtesy of the Ward, Alabama Museum.)

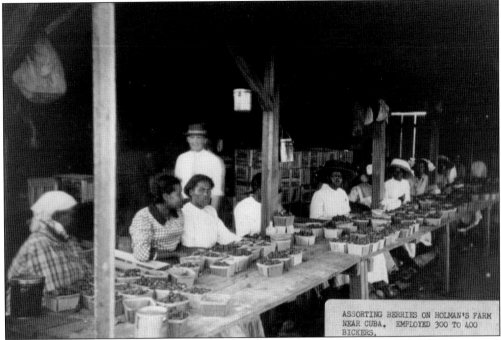

ASSORTING BERRIES ON HOLMAN'S FARM NEAR CUBA. EMPLOYED 300 TO 400 BICKERS.

In the early 1900s, one of Sumter County's most profitable cash crops was strawberries, which were shipped to Cincinnati and other Midwest markets. During the first half of the 20th century, Cuba was the strawberry capital of Alabama. Above, women are sorting strawberries for sale on Holman's Farm, near Cuba. The farm employed 300–400 people during picking season. The payroll fluctuated between $1,000 and $1,700 per week. Below, workers are standing in line to receive their weekly paycheck in the 1920s. (Both, courtesy of the Cuba Museum.)

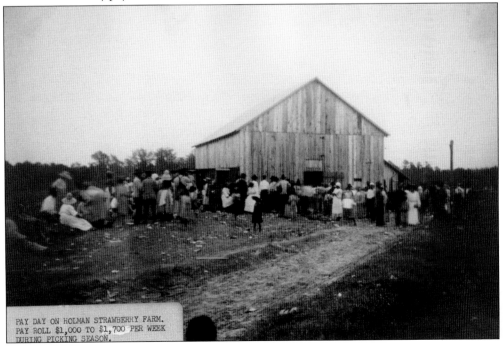

PAY DAY ON HOLMAN STRAWBERRY FARM. PAY ROLL $1,000 TO $1,700 PER WEEK DURING PICKING SEASON.

In this 1950s photograph, Robert Foy (left) and his employer Jack Crumpton are working together in the field. Robert was a tenant farmer in Emelle all his life. Professional photographer Annette Mitchell's photograph of Robert Foy's scarred and calloused hands (not pictured) illustrates the hard life he led in Emelle. (Courtesy of Lolita Smith.)

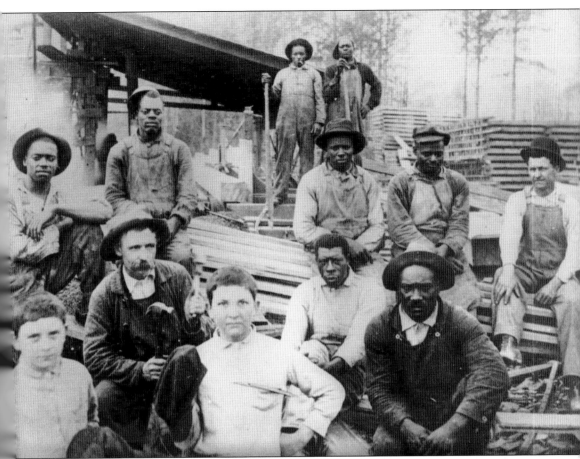

This photograph of John T. Walker's Cuba sawmill was taken in the early 1900s. The two boys in the front row are probably Walker's sons. By the end of the 19th century, the nation's timber production had shifted to the South. Through the use of steam engines and circular saws, which could cut 40,000 board feet in a single day, the production of saw timber increased from 1.6 billion board feet in 1889 to 15.5 billion board feet in 1920. (Courtesy of the Cuba Museum.)

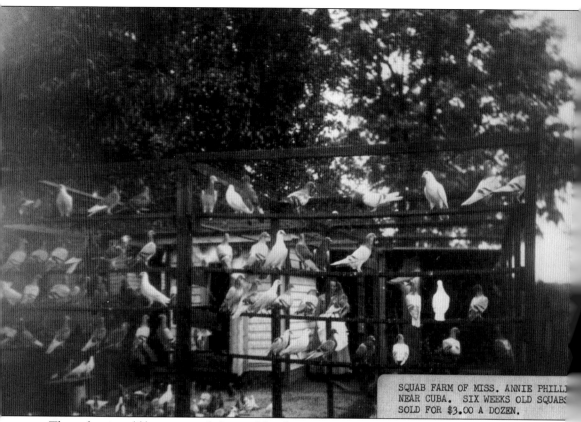

SQUAB FARM OF MISS. ANNIE PHILLI
NEAR CUBA. SIX WEEKS OLD SQUABS
SOLD FOR $3.00 A DOZEN.

Throughout world history, squab (pigeon) has been considered a delicacy. Kings and queens have dined on squab since the time of Ancient Greece. In America, Thomas Jefferson and William Randolph Hearst served squab at their dinner parties. In Sumter County, Annie Phillips raised squab on her farm near Cuba. She sold six-week-old pigeons for $3 a dozen. (Courtesy of the Cuba Museum.)

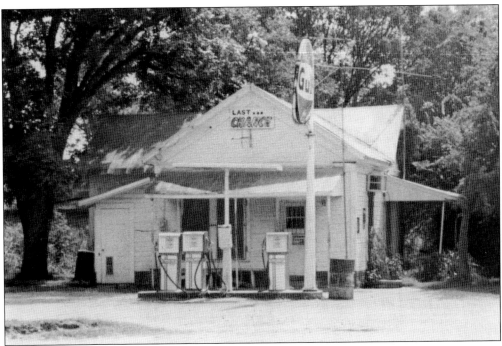

Built in 1912, the Last Chance Filling Station was one of the original buildings in Geiger. It also served as a grocery, post office, and tavern. The owner, Monroe Aust, believed that Jimmie Rodgers was born in a house that stood behind the Yellow Front Store. (Courtesy of Freda Brown.)

Before the underpass was built in York, the Mule Hide Station stood at the intersection of Highway 11 and 80 East on the AT&N Railroad. In 1930, the year this photograph was taken, Highway 11 and 80 East crossed the railroad tracks at this spot. The car seen here is a 1928 coupe. (Courtesy of the Cuba Museum.)

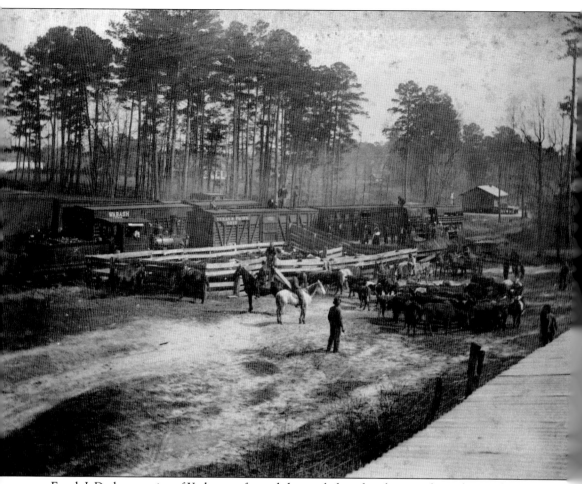

Frank I. Derby, a native of York, transformed the cattle-breeding business by replacing the Piney Woods cows with a breed from Texas that was immune to tick fever. After transporting carloads of the immune cows to Alabama by rail, he designed a dipping vat to eradicate ticks. In 1911, he invited representatives of the Alabama Cattleman's Association to his farm to view the dipping process. (Courtesy of the Center for the Study of the Black Belt.)

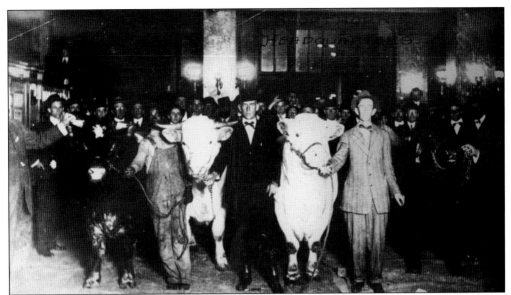

Because Derby believed that shorthorn cattle were best suited to Alabama, he traveled to the northern states and brought back shorthorn bulls for a sale in the early 1900s. He publicized the event by putting up two shorthorn bulls and one Aberdeen Angus bull in the Gay Teague Hotel in Montgomery. It went smoothly until the Aberdeen Angus attacked one of the shorthorns. No bulls were seriously injured in the resulting scuffle. (Courtesy of the Center for the Study of the Black Belt.)

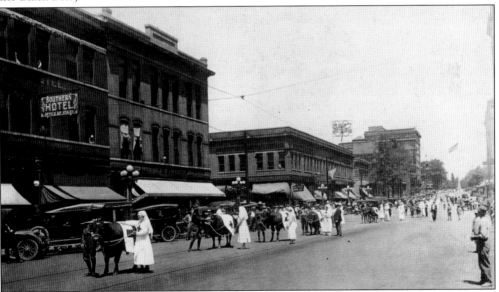

Frank I. Derby was too short to be accepted into the Army during World War I, so he contributed to the war effort by organizing a bull sale at the Tutwiler Hotel in Birmingham that would benefit the American Red Cross. By the time the date of the sale arrived, July 2, 1918, Derby had recruited 52 bulls for the sale. All of the proceeds, approximately $100,000, went to the American Red Cross. The name of one particular bull, Lavender Lord, was changed to Woodrow Wilson just before the sale. In this photograph, Red Cross nurses are guiding the procession of bulls down the streets of Birmingham. (Courtesy of the Center for the Study of the Black Belt.)

The grand opening of Derby's Chevrolet dealership in Eutaw was held in 1949. Frank I. Derby Jr. is seen handing over the keys to a brand-new Chevy Deluxe to an unidentified woman. In the background are, from left to right, Frances Palmer Derby, Frank I. Derby Sr., and Minnie Wade. (Courtesy of the Center for the Study of the Black Belt.)

In 1925, Frank I. Derby renovated a building on the western end of Fourth Avenue in York to create the Mule Hide Inn, a tourist hotel and lodging house. In this photograph, Frank I. Derby (left) and Robert H. Derby are standing in front of the partially completed building. The first event held in the inn's luxurious dining room was a reception for departing mayor J.H. Wallace. The April 3, 1925, edition of the *Sumter County Journal* proclaimed that the hotel would be "the object of much civic pride among the citizens." (Courtesy of the Center for the Study of the Black Belt.)

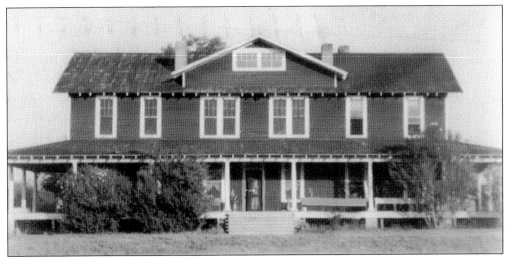

Because of Geiger's proximity to the railroad, John Hendrix Pinson believed that a hotel was necessary to accommodate all the people who would be coming to town to work and visit. After the first Hotel Noxubee burned, the Jenkins family constructed a second hotel in its place. Mrs. Jenkins is most likely the woman standing in the doorway. (Courtesy of Freda Brown.)

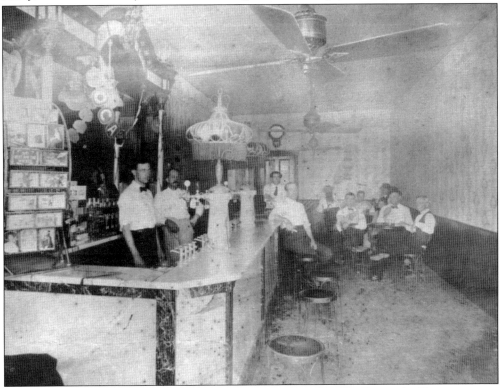

A.D. Beavers opened his soda fountain in Cuba in 1907. Prior this time, Beavers had been operating a general mercantile business in a building constructed during the Civil War. In the early 20th century, soda fountains were a social gathering place. They could be found in drugstores, train stations, five-and-dime stores, and department stores. Some even offered hot meals, as well as ice cream sodas. (Courtesy of the Cuba Museum.)

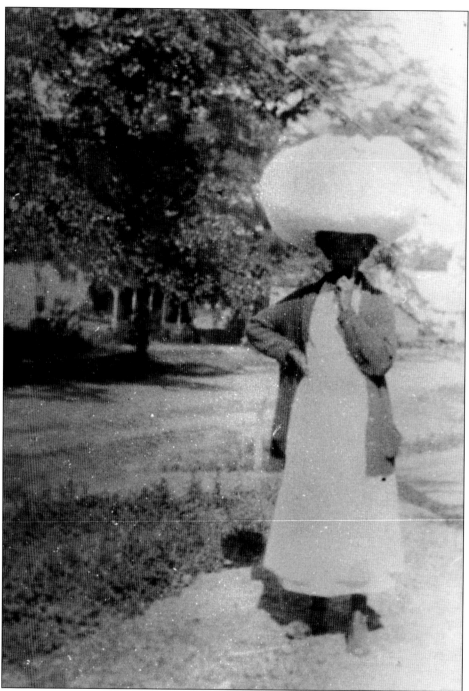

The practice of carrying a burden on top of the head dates back to the ancient world. In fact, the Book of Proverbs mentions the practice in the Old Testament. African women who were transported to America taught this skill to the younger women. Even in the early 1900s, black washerwomen, like Rose Thetford in Livingston, carried their white employers' laundry on their heads. The custom ended when whites began delivering their laundry to the washerwomen in automobiles. (Courtesy of Joe Taylor.)

BIBLIOGRAPHY

Brown, Alan, and David Taylor. *Gabr'l Blow Sof'*. Livingston, AL: Livingston Press, 1997.

Brown, Virginia Pounds, and Laurella Owens. *Toting the Lead Row*. Tuscaloosa, AL: University of Alabama Press, 1980.

The Heritage of Sumter County, Alabama. Clanton, AL: Heritage Publishing Consultants, 2005.

Jenkins, Nelle Morris. *Pioneer Families of Sumter County*. Livingston, AL: Livingston Press, 1961.

Jones, Tina Naremore. *Bridging Time: 175 Years at the University of West Alabama*. Virginia Beach, VA: The Donning Company Publishers, 2010.

Lyon, Ralph M. *A History of Livingston University: 1835–1963*. Livingston, AL: Livingston University, 1963.

Siebenthaler, Donna J. "Sumter County." *Encyclopedia of Alabama*. Web.

Spratt, Robert D. *A History of the Town of Livingston, AL*. Nathaniel Reed, editor. Livingston, AL: Livingston Press, 1997.

DISCOVER THOUSANDS OF LOCAL HISTORY BOOKS
FEATURING MILLIONS OF VINTAGE IMAGES

Arcadia Publishing, the leading local history publisher in the United States, is committed to making history accessible and meaningful through publishing books that celebrate and preserve the heritage of America's people and places.

Find more books like this at
www.arcadiapublishing.com

Search for your hometown history, your old stomping grounds, and even your favorite sports team.